MW00564094

ZONE

A PRACTICAL GUIDE TO REHEARSING WITHOUT A DIRECTOR

California State University
Fullerton

second edition

Kendall Hunt
p u b l i s h i n g c o m p a n y

MARIA COMINIS GLAUDINI

Cover images © 2017 Jordan Kubat.
Headshot on back cover © 2017 Dennis Apergis.

Kendall Hunt
publishing company

www.kendallhunt.com
Send all inquiries to:
4050 Westmark Drive
Dubuque, IA 52004-1840

Copyright © 2013, 2017 by Maria Cominis Glaudini
Revised printing 2015
ISBN 978-1-5249-3472-9

Published in the United States of America

For my students:

past, present and future.

It is because of your desire to understand, I persist.

Contents

Acknowledgments

In 2013, I published the first edition of this book and immediately realized a second edition was in my future. Writing about an instinctual process did not come easy because it is ever changing and improving. I am consistently inspired by students who desire to develop a productive independent rehearsal process in order to develop as artists and learn the craft of acting. Rehearsing in the Zone has evolved because students questioned, were curious and forthcoming on feedback.

I find joy in every rehearsal and believe everyone should or why participate. Rehearsal is work but also exhilarating when the collaboration is focused on the storytelling and not ego.

I am grateful for the artists in my life who have supported my passion every step of the way: Grace Scott, John and Charlie Glaudini, and Svetlana Efremova-Reed. To my teacher, Uta Hagen who gave me a strong foundation and belief that acting is a calling and to follow it. To Herbert Berghof Studio which was my home for many years where this process was born. To the artists in this book who shared with me their journey and wisdom. To my colleagues: Hugh O'Gorman, Chris Shaw, Sue Berkompas, and Leslie-Anne Timlick for their thoughtful criticism and support of this text. For the Michael Chekhov teachers who opened the door to my imagination: Joanna Merlin, Ragnar Freidank, Jessica Cerullo, and the late Mala Powers at MICHA. To the National Alliance of Acting Teachers for the next chapter in my artistic growth. And finally, to all my students who I have ever had the pleasure and honor of teaching: you have inspired me with your eager, hungry hearts, and earnest souls, who with your desire to change the world has given me the "need to speak" every day of my life.

Please feel free to email me at MCominis@fullerton.edu regarding questions about this process and updates on future workshop schedule.

Introduction

When preparing a scene for acting class, students are expected to rehearse independently with their scene partner. Students share rehearsing independently can be frustrating for many reasons and these challenges are rarely addressed in class.

> *We are in conflict about how we should play our parts.*
>
> *How do we block the scene? Usually a director tells us this.*
>
> *My partner just wants to wing it but I feel like we should rehearse.*
>
> *We rehearse and talk, but we never get anywhere.*
>
> *I do hours of character biographies and research but I don't know how to apply it to the scene.*
>
> *What exactly are we supposed to do in rehearsal?*

Rehearsals can often be grueling without a director. Skill level can vary greatly from actor to actor, which makes working with peers challenging. Without a leader, actors often don't know what to accomplish in rehearsal and more often end up either telling each other what to do, or accomplishing nothing. Has another actor ever told you how to play your character? Maybe this sounds familiar: *I think we should play this moment with you crossing over to me on this line and be like, you know, in my face, really angry.*

How does an actor learn a process when they are directed by a peer and not given the freedom to explore choices for themselves? And how is the actor who is directing the scene ever going to know how to play in the moment when they are outside of the scene giving result-oriented direction? Not only does it paralyze the creativity in the room, the actors involved will never find autonomy.

You might recall working with the "but actor". This is the actor who contradicts everything. *But I don't think my character would do this. I don't think your character would say it that way.* In basic improvisation class the first rule you learn is to agree and to say "yes and…" and add on to it. "No but…" limits your choices and closes you off to all possibilities. While *Rehearsing In The Zone*, partners will respectfully allow each other to explore the play and their choices without judgment or contradiction.

What is *the zone?* Musicians are taught that "how" they rehearse is "how" they perform. Similar to the musician, who works on a particular musical passage until it is effortless, the actor learns how to work collaboratively through specificity and concentration, exercising possibility and flexibility in search of

choices that are clear and based in truth. Most musicians cannot play a piece of music fluidly the first, second, or third time while they are training. Neither can the actor. It takes time and productive training to embody these skills. *Rehearsing In The Zone* is the actor's road map to independent rehearsal and the teacher's resource to help students apply whatever acting technique is being taught.

I remember hearing a story about Estelle Parsons, three-time Tony Award nominee and Academy Award winning film and television actress. She was working with a regional theatre company at the time with a colleague of mine. At the first rehearsal, she addressed the cast and said: *I want you all to know, I am going to be dreadful for the next few weeks until I figure the character out.* She gave herself permission to not have the answers right away. She had faith in her process, and given time and exploration she would find the characterization truthfully. When I had the pleasure of speaking with Ms. Parsons, I asked her if the story was true and she replied, *Probably. I don't remember but it sounds right.* Sometimes you have to make the wrong choice to recognize the right one. I often hear the argument, "In summer stock, we are expected to PERFORM".

Performing and rehearsing are two different skills. Once your acting process is based in truth, you will understand the transition from rehearsal to performance but if you jump right into performance before you know what you are doing, you will fall into bad habits and your acting will remain superficial.

By Rehearsing in the Zone STUDENTS WILL

> Find their autonomy as actors
> Use time efficiently and establish a work ethic
> Apply technique (any acting technique)
> Gain confidence with a strong point of view
> Eliminate actor conflicts
> Implement strong character-driven choices from the beginning
> Find rehearsal an exciting and creative place to discover

TEACHERS WILL

> Find students more prepared
> Raise the level of the class
> Save time in class for teaching acting
> Reduce potential student conflicts
> Eliminate resistance

Part I Process

How does the actor move us to tears, laughter, and take us on an emotional journey that brings us to catharsis every time? There is method to this madness we call acting. Whether you are training in Konstantin Stanislavski, Stella Adler, Uta Hagen, Sanford Meisner, Michael Chekhov or any of their protégés, acting technique is developed in rehearsal.

Learning technique occurs in class with your teacher but applying technique happens during independent rehearsals with your scene partner with a well-written play in hand, under the magical lighting of a black box studio and two artists who trust each other and the process of what's to come. Sometimes, when actors rehearse with their partner without a teacher or director, rehearsal can be challenging.

Part I of *Rehearsing In The Zone* offers pre-rehearsal preparation, rehearsal goals and practical exercises for integrating technique into your rehearsal process. It also provides solutions to common challenges when choosing the path to act as a career. It hopes to establish a foundation of productive work habits which serves the actor as a stepping stone towards creative success in the acting arena.

"An actor must burn inside with an outer ease."

—Michael Chekhov

FOUNDATION & TERMS

In your choice is your talent.

-Stella Adler

Is acting teachable? Anyone can learn a process and obtain skills, but talent is a gift you are born with. Aptitude is a necessary element in any profession. You wouldn't dream of becoming a doctor if you didn't excel in the sciences. How do you define the actor's talent?

Talent is born from a deep desire to express yourself, to tell stories, which compels you to move others. Actors view the world quite differently than others. Actors naturally question humanity with curiosity. They notice things; others do not. With keener senses, there is a deeply rooted passion that drives them to share, to imagine, and then to act.

Many people will discourage you from becoming an actor. It's one of the most competitive fields, but anything worth doing is often challenging and difficult. There are no shortcuts to becoming an actor. Reality television has glamorized the notion of *celebrity*, where *anyone* can get his or her fifteen minutes of fame. But becoming an actor, not a celebrity, is quite different. It takes years of tenacity and hard work to build your instrument as an actor, as well as a body of work to show for it. No matter what others may tell you, training is important. The field you are studying *is* competitive, so why wouldn't you want to enter the field as prepared as possible?

TRAINING

Where to start? What technique? Do I need a degree? There are as many acting techniques as there are teachers. It can be overwhelming to know *which* technique to learn, what school or conservatory is best. For every actor the answer will be different. Some people will thrive in an academic setting while others will suffocate. Some will flounder in a conservatory

setting and others will flourish. And surprisingly enough, some will succeed even without any training. You can see there is not one way to Rome. All that really matters is that once you get there, *you* know what you're doing.

Since you are reading this book, you are probably in class and earnestly working on your craft. This is wise, since becoming an actor is a process of developing your imagination and your life as an artist. School can be a structured and safe place to learn, away from the pressures of the real world, but keep in mind, it's merely a microcosm of the profession.

The difference in acting from other professions is that you are the instrument, so you must begin with yourself. Not unlike the dancer, you are the vehicle. It's difficult to play someone else truthfully until you know who you are. The craft of acting will demand you are passionate and curious about the world. It will ask you to look at yourself honestly and objectively. Fundamental training teaches characterization through identification. Most beginning classes will teach self-expansion exercises, where you develop objectivity of self, sensory skills, and physical, and spacial awareness. Training will help you access a wide range of emotions, vulnerability, and a sense of truth in relationship to others and the world you live in.

All effective acting techniques will agree that *believable truth* comes from deep within *you*. Believable truth also relates to the playwright and the venue you are performing in. All truth must initiate from an inner faith and belief. If you are playing Shakespeare in the park, your truth will have a more physical and theatrical sense of truth. If you are acting in film, your truth will be much more internal.

Training should challenge you if it is going to prepare you for the profession. Challenging students is what teachers and coaches do. Jerzy Grotowski, the great Physical Theatre director, approached acting as a sport. It is a sport and craft and there is nothing passive about it. The form of the word is **ACTIVE**. Your acting teacher/coach is not all that different from an athletic coach. A great teacher should push you out of your comfort zone and demand that you bring your best, every time. It is my belief that acting class should never resemble a cultish religion where the teacher acts as guru and intrudes in your personal life. A great teacher can help you tap into your personal choices and depth and act as a mentor, they should not act as a therapist or best friend. Class should make you independent, not codependent on the teacher.

Acting class should be a safe place where you learn a tangible process to truthful characterization, develop your humanity and connect deeply to your fellow artists.

Acting Class is intended to be challenging for you to grow. Growth can be very uncomfortable. Psychiatrist and Rabbi Abraham Twerski says, "stressful times signals growth," and if we use adversity properly we can grow through adversity.

He uses the metaphor of how a lobster grows a new shell. The lobster's a soft mushy animal that lives inside a rigid shell does not expand. When the lobster grows, the shell is confining. So, the lobster goes under a rock formation, sheds the shell, and grows a new one and repeats this process over its' lifetime. The stimulus for the lobster to be able to grow is that it feels uncomfortable.

Acting class will be uncomfortable. It is supposed to be. Any higher-level training should be if it is going to stretch you and help you develop your skills to prepare you for the profession. Many students don't understand this when they choose to major in the arts. That is not to say it shouldn't be enjoyable. The joy will come from the satisfaction of overcoming the challenge and reaching new levels in your work.

A BRIEF HISTORY OF MODERN ACTING

Konstantin Stanislavski devoted his life to the study of human behavior to bring real life to the stage. He studied and "tested all ideas that came his way and tried any exercise from any plausible source-yoga's relaxation and visualization, Dalcrooze's eurhythmics, psychological theories of emotion from France and Russia etc., etc.". [1] His work peaked during Stalin's Russia, a time where censorship dictated what research was permissible. Any teachings remotely spiritual, anything having conflict or tested the ideology of the state, was not allowed. Nevertheless, he continued his work. By the time Stalin was in power, Stanislavski was already well-known and his work was tied closely to his language. Instead of leaving Russia, like many of his colleagues, he chose to stay. He was given a place to live, a few students to work with while his teaching and research was managed and censored. However, his work continued under the radar with the help of his last assistant, Maria Knebel.[2] His research was continuous through to the end of his life and what many American students don't know is how it changed, interpreted, and was buried. Scholars and artists who share the evolution of his work are among us and students should continue to discover his deep meaningful understanding of the human condition, which is not only useful for psychological realism but for every genre or medium.

[1] Carnicke, Sharon Marie. *Stanislavsky in Focus*.
[2] Carnicke, Sharon Marie. *Actor Training*. Edited by Alison Hodge, Routledge, 2010.

America's formal study of acting began with interest in Konstantin Stanislavski, founder of The Moscow Art Theatre, and his student Yevgeny Vakhtangov during Moscow Art Theatre's visit to America in 1923 and 1924. After listening to a series of lectures led by Richard Boleslavsky, from Stanislavski's American Laboratory Theatre in New York, Director, Harold Clurman, Actor/Teacher, Lee Strasberg and Producer, Cheryl Crawford created the collective known as The Group Theatre in New York City. The Group members trained and performed together, driven by a unified fervor for the discipline; under Harold Clurman's direction. Broadway and the style of American acting was changed for forever because of The Group. The Group Theatre members[3] took to studying Stanislavski as an ensemble, while applying technique to performance. Transferring a more realistic and truthful style to acting on the Broadway stage was revolutionary, since in the late 1920s acting was stylized, affected, and far from truthful. Despite The Group's artistic success and the enormous impact they made on the American theatre, after ten years the Group disbanded. Over the years, members branched out opening their own schools, which grew out of unanswered questions with Stanislavski and acting challenges of the time. Most acting schools that train actors today evolved out of The Group Theatre and are based on some part of Stanislavski's System.

AMERICAN TRAINING INSPIRED BY STANISLAVSKI

Lee Strasberg immigrated to the United States from Eastern Europe in 1901 as a young child. Strasberg coined the term: *the method*, which scholars refer to as *his* take on Stanislavski's System. Like his colleagues, he was inspired by The Moscow Art Theatre's, American Lab Theatre series of lectures, led by Richard Boleslavsky and Maria Ouspenskaya. Strasberg was particularly passionate over *Affective Memory*. He utilized the actor's tragic and emotional experiences to access what he referred to as the *golden keys*.[4] Many actors in The Group resisted *affective memory* but Strasberg adapted this element into his own technique. Strasberg is often one of the most controversial characters in this group of Master Acting Teachers because of his personality and his often, noted disregard, and lack of sensitivity. He is credited as one of the cofounders of The Group Theatre. In 1948, he was asked to join The Actor's Studio after Elia Kazan, Bobby Lewis, and Cheryl Crawford established its' success and in 1951 became Artistic Director.

[3] The Group consisted of directors, actors and playwrights, including: Elia Kazan, Stella Adler, Robert Lewis, Will Geer, Paul Green, Clifford Odets, Sanford Meisner, Marc Blitzstein, and others.
[4] Brestoff, Richard. *The Great Acting Teachers and Their Methods.* Smith and Kraus Publishing, Lyme New Hampshire, 1995, p. 80.

Bobby Lewis and Elia Kazan both actors became successful directors who were key players in The Group Theatre and founded The Actor's Studio together with Cheryl Crawford. Lewis had a falling out with Kazan in 1947 and went on to teach acting at Yale School of Drama and taught acting to the end of his life.

Kazan went on to become a renowned Broadway and film director earning both Academy and Antoinette Perry Awards. His seminal films were ON THE WATERFRONT, which earned him Best Director.

One of the lead actresses in The Group was Stella Adler who was born into a theatrical family. Her destiny of living a life in the theatre was clear from early childhood. Adler was one of the most experienced actors when she joined the Group Theatre having performed her whole life including on Broadway and in Vaudeville. She founded both Stella Adler studios both in New York City and Los Angeles, which still trains actors today. The process *Affective Memory* made her hate acting. When she shared this with Stanislavski, he offered to teach her in France and shared his new findings. Adler expressed the most important element of the method was imagination, or Stanislavski's *Magic if*? Her training focuses on the play's given circumstances and allowing the environment of the world to inspire behavior.

Sanford Meisner was born in 1905 in Brooklyn, NY, and founder of The Neighborhood Playhouse. He had an education in music and began his career with the Theatre Guild, a theatrical society that produced non-commercial works. While in the Group Theatre he did not respond to Lee Strasberg's use of Stanislavski's *Affective Memory* work or the analytical aspects of the system. Meisner focused on what he felt was the most important teaching of Stanislavski's teaching, the element on *Communion* which is developed in Meisner's *Repetition Exercise* exploring and deepening the relationship between scene partners. His technique also developed out of Stanislavski's *Magic If*. He is credited with the most common definition of acting, which is commonly used today as: *living truthfully under imaginary circumstances.*

In 1945, Herbert Berghof (Austrian-American, actor, theatre director and charter member of The Actor's Studio) founded HB Studio in New York City as a creative home for theatre artists to practice and learn their craft from other working professionals. A few years later, his wife, Broadway actress, teacher and author, Uta Hagen joined him on this mission and began her life long work as a teacher, examining behavior and truth in characterization. This was my artistic home in New York City where I studied with and taught under Uta Hagen's tutelage from 1993–2003. It is where I found my work as a teacher was as important as my work as

an actor. In 1973, Uta Hagen was one of the first actor/teachers in America to articulate the process of acting with her renowned publication of *Respect for Acting* and in 1991 published *A Challenge for the Actor,* which addresses fundamental acting exercises that addresses every challenge actor will need to solve.

An original member of Stanislavski's first studio of actors, which inl-cluded Yevgeny Vakhtangov, Richard Boleslavsky and Maria Ouspenskaya (American Laboratory Theatre), Michael Chekhov had his own ideas about characterization. Michael Chekhov, nephew to Anton Chekhov (playwright), was Stanislavski's most successful student. An Academy Award nominee, he became a well-known theatre practitioner in Hollywood, California during the 1950s and trained many celebrated actors. Chekhov explored how to create characters by nonanalytical means and his work grows out of psychophysical integration utilizing imagination over intellect.

The Actor's Studio, HB Studio, Stella Adler Studio and The Neighborhood Playhouse were seminal in establishing the foundation of American acting. Training a new generation of actors each year, they continue to carry on the traditional groundwork of truth, discipline, and character-driven choices.

THE PHYSICAL WORLD OF ACTING

Bertolt Brecht created Epic Theatre and his theory of alienating the audience was to provoke and make them think. His work as playwright and poet was to comment on the world as he saw it and to provoke an audience to be bothered and disturbed by what they saw not emotionally involved. Playing Brecht calls upon many different training modalities. Brecht uses music, clowning, circus training, and direct confrontation to the audience. Its themes are political and points to current issues. The acting style is not realism but has its roots and connection to Stanislavski all the same. Its roots connect more to producer, director, actor and Stanislavski's collabo-rator, Vsevolod Meyerhold's Biomechanics. Meyerhold and Brecht utilized storytelling with large physically expressive movement and believed that emotions could be elicited from large gestures.

Jerzy Grotowski was also influenced by Stanislavski and realized his "poor theatre" as inspired by Antonin Artaud, Theatre of Cruelty. He cre-ated work, simply and professed all that is needed is a spectator, a space, and actors. Grotowski is of service to the theatre as a sport and developed specific exercises to turn the actor into an athlete, call *plastiques.* Later he returned to Stanislavski's use of physical action and believed it was key in storytelling.

There are similarities and differences in all approaches to acting. The common language used today was born out of the work achieved by our founding fathers and mothers of the American Theatre. *There is wisdom of the mind, and wisdom of the heart*—the actor must find this connection to act.[5]

To bring the play to life the actor uses intellect, imagination, and personal experience.

We will start with Intellect.

The following key terms will help you acquire common terminology used in the craft of acting. Articulating what we do helps the actor talk the talk and walk the walk.

The following key terms are some of the common terms used in actor training. On the next page I have defined them. They are an amalgamation of many acting techniques, including Stanislavski, Hagen, Meisner, Michael Chekhov, Clurman and others.

KEY TERMS			
Action	Acting Score	Adjustment	Affective Memory
Anticipating	Archetype	Atmosphere	Beat (bit)
Behavior	Chemistry	Commenting	Destination
Emotions	Environment	Events	Given Circumstances
Images	Imagination	Impulse	Indicate
Indulgent	Inner Objects	Inner Life	Intention
Intuition	Kinestheic Response	Moment Before	Moment to Moment
Objective	Obstacle	Psychophysical	Relationship
Sensory Recall	Substext	Super Objective	Tactic
Trigger	World of the Play		

In parenthesis is where more information on this term can be found. There is cross over with techniques for many of these terms, and these terms are certainly not definitive.

[5] Charles Dickens.

ACTION: Action is a mental and physical energy, a life force utilized from the actor's will. It is what the character does to the other character to get what they want. Action can be played directly or indirectly. Indirect action is often played when the character finds it hard to look at their partner. Action is not effective when played passively or laissez faire, though it can be subtle and finessed. Action is more effective if it is played with ease and not force. Effort is not action (Aristotle, Stanislavski).

ACTING SCORE: (scoring the role) the character's series of actions in the play. Similar to the orchestra conductor's score, which has interpretation, dynamics. However, scoring the role does not mean mandating action or preplanning choices but the actor's collected inspiration for the role. It includes the scene/play, which the actor perpetually refers to for inspiration and truth in answering the who, what, where, and why (Stanislavski, Hagen).

ADJUSTMENT: 1) A correction an actor makes in response to a director's note and 2) a spontaneous change in the moment to moment truth.

AFFECTIVE MEMORY: It is recalling details of a significant memory to evoke emotion (Stanislavski, Strasberg).

ANTICIPATING: Knowing what is going to happen before it happens (Hagen).

ARCHETYPE: An archetype is a prototype, an image of a person who typifies something specific (Jung, M. Chekhov).

ATMOSPHERE: The intangible energy of the world of the play (Stanislavski, Chekhov).

BEAT (BIT): A small section of action. Beats are used differently by playwright, director, and actor. We will utilize larger beats for rehearsal purposes. Also, referred to as a unit of action (Stanislavski, Adler, and Hagen).

BEHAVIOR what the character does physically in response to the given circumstances and relationships.

CHEMISTRY: The palpable, electric energy between people.

COMMENTING: Showing the actor's idea about the character rather than being in the moment of truth and living truthfully in the character's given circumstances. Commenting can be found in showing with the face and lack of mind/body connection.

DESTINATION: Movement out of purpose and need (Hagen).

EMOTIONS *are the springboard to action* (Hagen). Emotions fuel action. They are utilized as an obstacle, which are overcome through action.

They are what gives the character pathos and why an audience cares for them. Emotions give empathy but if played or forced can lead to indulgent acting.

ENVIRONMENT: The concrete place in the world of the play.

EVENTS: Extraordinary things that happen to a character in a play (Stanislavski).

GIVEN CIRCUMSTANCES: Facts the playwright reveals to you in the play as truth. What happens. Who you are. All the Who, What, Where, When, and Whys.

IMAGES: Visual pictures in your mind's eye.

IMAGINATION: *Magic If* (Stanislavski). Informed by the five senses. *The senses are the door to the imagination* (Hagen). *Acting is living truthfully under imaginary circumstances* (Meisner).

IMPULSE: Involuntary response prompting action.

INDICATE: Showing the character rather than behaving truthfully. Really doing, prevents indication.

INDULGENT: Excessively enjoying emotions where the actor is aware of themselves and belaboring the moment so the scene does not move forward.

INNER OBJECTS: The images of the actor's own experiences or imagined experiences seen in the actor's mind's eye (Hagen).

INNER LIFE: Internal stimulus. Psychological thoughts stimulating emotions which lead to action.

INTENTION: What you intend to do. (Meisner)

INTUITION: The sixth sense. Your gut response. Following it will help you follow impulse.

KINESTHEIC RESPONSE: The spontaneous reaction to a motion that occurs outside of oneself, an instinctive response to an outside stimulus (Anne Bogart/Viewpoints).

MOMENT BEFORE: The preparation before you enter the stage as the character. It is the transition from actor's givens to character's givens.

MOMENT TO MOMENT: Not ahead, not in the past but in the immediate now (Hagen, Meisner).

OBJECTIVE: What the character wants from the other characters in the scene. Once achieved, a new objective is needed (Stanislavski)

OBSTACLE: What gets in the way of the objective. Emotions, other characters, conditioning forces, environment, given circumstances can all be part of obstacles. Obstacles are overcome by action (Hagen, Adler).

PSYCHOPHYSICAL: Mind and body connection.

RELATIONSHIP: How you feel about the other person, what you do physically and how you speak to the other person all define relationship. Who leads? Who follows?

SENSORY RECALL: Utilizing your five senses to explore physical sensations such as fatigue, drunkenness, and headache. *The senses are the door to the imagination.* Sensory recall is how we utilize physical sensations. Locating where the symptoms are on your body and what we do (behaviorally) to overcome them is how we act the physical challenges of a play (Hagen).

SUBSTEXT: What is said between the lines. The character's inner monologue. (Stanislavski)

SUPER OBJECTIVE: What the character wants/pursues throughout the entire play. (Stanislavski)

TACTIC: Synonymous with action. (Meisner)

TRIGGER: Something that another character says or does that informs a change in action or point of view. A trigger can also be a sensory stimulus that triggers an impulse of behavior.

WORLD OF THE PLAY: The physical, sensorial, and atmospheric world where the characters exist, established by the playwright.

PLAYWRIGHTS CLUES ABOUT THE CHARACTER
PUNCTUATION

Italicized text means give more emphasis

Ellipsis. . .hesitation

Double dashes-- interruption

Dialogue written side by side: characters dialogue overlaps.

Single alternating lines: stichomythia, a rhythmic exchange of text used in verse drama but can be found in contemporary plays such as those by David Mamet, John Patrick Shanley, and Rajiv Joseph.

Note: The Open Scenes in Chapter 3 will provide opportunities to exercise these clues.

PRE-REHEARSAL PREP

Most people do not listen with the intent to understand;
they listen with the intent to replay.

-Stephen R. Covey

READING THE PLAY

Acting is developed through intellect, imagination, and personal experience. Your imagination interprets the play and informs what the play means to you on a personal level. We respond to stories from the bedrock of our experiences. Without distractions, allow yourself the opportunity to fully enter the world of the play and read the play with no judgement. Read to understand not to just get through it.

Analysis is part of the acting process but sometimes it can overwhelm and stunt the creative process. Approaching analysis creatively can spark less academic responses and more personal connections. In the following exercises, I ask you to read the play from varying points of view, which invites you to hear it and visualize the play differently. This process allows the play to work on you.

Concentration is one of the most important skills you need as an actor. Reading the play for understanding requires a flow so choosing where you will read will be important. Quiet spaces are sometimes a challenge to find but necessary for you to fully invest.

Each read through of the play and exercise which follows the read through, corresponds to each Zone rehearsal found in Chapter 3. For example, Reading 1 as first visit and Exercise 1 are to be done prior to Zone 1 rehearsal.

Reading 2 as second visit and Exercise 2 are to be done prior to Zone 2 rehearsal.

Reading 3 from the character's point of view and Exercise 3 (character narrative and walk and talks) are completed prior to Zone 3.

FIRST VISIT: FREE-ASSOCIATION WRITE

Enter into the world of the play, open and eager to receive the story with a beginner's mind. Imagine you are a virgin to this world of the play and enter with a childlike innocence. You are a visitor in a brand new world. It is *never* a good idea to rent the movie of the play you are about to work on. It will only lead you to impersonating someone else's performance.

EXERCISE 1: BEFORE ZONE 1 REHEARSAL

AFTER FIRST READING OF THE PLAY

Immediately after you read the play, set a timer for 15 minutes and free-associate write whatever comes to mind. Do not worry about grammar or spelling and write as quickly as possible. When the timer goes off, stop. Close your book and walk away.

Most students underestimate fifteen minutes. Allow yourself the time to daydream and write a response. It might feel tedious but development as an artist is in the details. This is an opportunity to express your thoughts without any influence from anyone else. Finding your voice takes time. You may surprise yourself at the things you notice if you fully invest the time and attention to the work. Explore the range of feelings and emotions you have after reading the play for the first time.

SECOND VISIT: SENSORY

Read the play again preferably a few hours later or the following day. Just don't allow a week between read one and two. Just like when you visit a place for the second time, you see things missed the first time. Allow all five senses to take in the world of the play. What are the smells, the sounds, the tastes, the images, and the textures of the world? As you read, notice if they initiate an emotional response within you. Our senses are more heightened when we remain in this wondrous state, so be a sponge and absorb the play with all your senses.

EXERCISE 2: BEFORE ZONE 2 REHEARSAL

AFTER SECOND READING OF THE PLAY
IMAGERY

Immediately after reading the play for the second time, set a timer for 15 minutes and draw a picture of images the play might have inspired.

Draw what's in your mind's eye. If you are like me and you can't draw, it doesn't matter. You are exercising a different part of your brain and no one will ever see this picture, it is for you to exercise images and actually ask the question: What do I see in this play? What's there? Use color if you wish.

SCAVENGER HUNT

Uta Hagen said, "the senses are the door to the imagination."

Collect sensory items for the world of the play and your character.

- In the earlier exercise, you explored images the play has left you with. Search for artwork, images, and photos that inspire you for the role. Perhaps there is something that reminds you or connects you personally to the play. Begin to collect your images.
- Find music that speaks to you for the play.
- Find smells that inspire the play. What permeates the world of the play with scent?
- Find textures that inspire you. Is the essence of the character cotton, wool, or silk?
- What are the tastes? Is there coffee, tea, wine, and foods that are in the play to bring you in.

Bring your scavenger hunt findings to Zone 2 rehearsal to share with your partner.

THIRD VISIT: CHARACTER READ THROUGH

Once you have chosen the character you are going to work on, enter the third reading from the point of view of the character. Take everything personally in this read-thru.

Read the play as if it is happening to you. **Never judge the character**. Think of yourself as their ally and enabler. You help carry out their mission. If someone was going to say something negative about this character, you might get defensive and take it personally.

Sometimes students find it helpful to schedule the third read-thru of the play with their partner and they read the play together out loud dividing up all the characters. If you choose to do this make sure you have the time to read it in its entirety. Once you finish the reading you can leave your meeting and do the following exercise on your own. Be careful. You may want to chat about the play. I like to think that a play's impact on us gets stronger if it goes unvoiced for while. Many of us are so easily influenced by others' opinions. As you are developing your artists' voice, allow it to develop without others' influence.

EXERCISE 3: BEFORE ZONE 3 REHEARSAL

AFTER THIRD READING OF THE PLAY

PONDER THE PLAY

Set your timer for five minutes. Close your eyes for five minutes and allow the play to play on you. Just allow images to come and go as they please. If you found music in the last exercise, put it on while you ponder the play. If there were any other successful finds in your scavenger hunt you can access them while you ponder.

CHARACTER NARRATIVE

This writing exercise will explore the character's point of view. After three attentive readings of the play, the characters, places, and events should be vivid in your mind. Reflect on what your character does in this play? Write this personal/character narrative as if it were you, sharing what you have done, what has happened in your life, and how it has made an impact on who you are. What you do will help you define who you are. The narrative will develop as you learn more about who you are in this play with each rehearsal. Nothing in this prerehearsal work is set. It's all exploration as is your rehearsal process. In your narrative include the following:

- What you do and to whom?
- Whom you are in relationship with?
- What are the major events of your life?
- Beginning of play
- Middle of the play
- End of the play
- What is your purpose in this story? Is this your story? Are you an important part of someone else's story.
- Is there a diagram or picture you create that might help clarify your journey? Sometimes a family tree can help you visualize the people in your character's life and how they connect and affect each other. Sometimes a piece of artwork can inspire you. Search. You will know it when you see it.

The timer is to help you forget about time and find flow to get in the zone.

PAGE TO STAGE

At this point, you should have a strong sense of the play and your connection to it. The next step is how the actor goes from reading to doing. Page to stage is forever a conundrum in our process. Your individual work will now take a leap to your feet before you go get in the zone with your partner.

QUESTIONS THAT BUILD CHARACTER

The following questions are intended to arouse and spark the character within you. As soon as your thoughts flow, get on your feet and walk and talk your answers. Allow the body to connect to the answers. Keep in mind your preliminary homework of three reads and exercises should inform your flow. Let it flow from you as if it were the character's monologue.

WALK AND TALK

Think of this as an improvisation on how much you know about this character. These questions are prompts. Allow these prompts to take you where they take you. Don't over think it. As soon as an impulse comes, follow it. You and your partner will share this exercise in Zone 3 when you invite character.

The Questions

Actions

> What do I do in this play?

> What are the events that take place in the play? Beginning, Middle, and End.

Objective/Want

> Based on what I do in the play, what do I want?

• Some possibilities:

Love/Joy/Passion	Power	Self-worth
Wealth	Acceptance/Validation	Purpose/Fulfillment
Power	Peace	Freedom
Security	Balance	Justice
Fame/Notoriety		

Tell me what a person does and I will tell you who they are.

-Uta Hagen

Example: What does Hamlet do in the play? He receives the ghosts' message. He puts on the play to test Claudius' reaction, once his own life is at stake, he proceeds toward revenge. Does he want revenge? His father's ghost comes to him because he cannot rest in peace and provokes the living to get it. Does Hamlet want revenge, justice, or peace?

What Hamlet does:

Receives his father's ghost

Questions

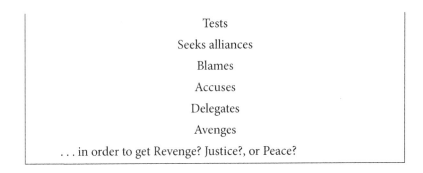

Tests

Seeks alliances

Blames

Accuses

Delegates

Avenges

. . . in order to get Revenge? Justice?, or Peace?

It will depend on the director's point of view but this is one way to add up the character's actions to find the super objective of the play. Ultimately, Hamlet does get peace in the end of the play but is that what he wanted and is there peace in his death? This kind of work will spark exciting collaboration with directors in the future. If you're an actor who asks these questions you will be a vital player.

Who Am I?

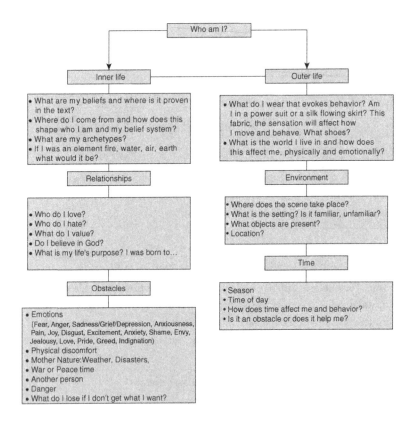

Trust the time you put in individually as it will pay off when you are in rehearsal. It's called a play so this process enables you to play with the play. I wish I could say that after you become a professional that you don't have to read the play as many times but Anthony Hopkins said it best:

"I have this obsessive need to—well I'm obsessive...uh to go over the text over and over and over. I do it 250 times, not the entire script but I just take what I have to, cause I want to be so sure that I know what I'm going to be doing...all kinds of weird things start to happen or like with "Silence of the Lambs", tones of voice, images come to me, and so it's my Stanislavski approach to do it that way, cause I believe you can only act if you're relaxed".[1]

THE RULES & AGREEMENTS

Most actors are not fond of rules. Rules imply "DO NOT", which can feel limiting to the actor who must always inhabit a sense of curiosity. After all, it is called a play. However, students have shared this presence of "play" without structure, while fun can accomplish nothing. Play and joy should always be present in rehearsal but for actors to achieve rehearsal goals independently, it is important to set the tone, which makes it possible. The following rules give every opportunity to succeed in rehearsal.

> Rules must swim in water, which is freedom. You must be free in combining the rules, which govern us, as with the letters of the alphabet. The final culmination depends on our artistic instinct, our artistic freedom, and our artistic feelings.
>
> -Michael Chekhov

1. ESTABLISH A REHEARSAL SCHEDULE AND STICK TO IT. Don't be late. Do not reschedule at the last moment unless it is an emergency. Everyone is busy. Be respectful of the time your partner set aside for you. It's unlikely an emergency will happen each week.

2. COMPLETE PRE-REHEARSAL HOMEWORK BEFORE REHEARSAL. If you or your partners have not completed the pre-rehearsal preparation prior to the zone rehearsal, it is a waste of time to rehearse. If your partner has not read the play, either by admission or by his or her choices, address it and reschedule the rehearsal until the preliminary work is complete. If you try and accomplish rehearsal, it's a waste of time.

3. REHEARSE IN A STUDIO. After ZONE 1, use a studio unless your scene takes place outside. However, if it is outside, also rehearse in a studio before presenting for a workshop in order to adjust. Discovering the world of the play can only be accomplished in a neutral space. Rehearsing in apartments with roommates—or worse, parents—will never allow you and your partner to really believe in the world of the play. It's unlikely you will enter "the zone" due to distractions and the obligation to please your eavesdropping

[1] An interview with James Lipton Inside The Actor's Studio Season 4 Episode 7, Anthony Hopkins.

audience. You will be exploring the character's world and will need to set up your environment/place so you will create fertile ground for your physical choices. If you rehearse in a public place such as outdoors or in another place than a studio, you don't want to mistakenly get the attention of the police or worse have someone interfere with the wrong motive. Take precautions and never use any prop that looks anything like a real weapon. Rehearsal space is a commodity in most acting studios and theatre departments, even more reason to come to rehearsal prepared.

4. USE ONLY THE TEXT. Once rehearsal has begun, the only words spoken are those written by the playwright. Yes. NO TALKING. The point of 'no talking' is to allow both actors to get in 'the zone'. Pianists play for hours and lose track of all time when they are rehearsing in "the zone". Artists can paint endlessly when they have a deep ache to complete their image. It is true for actors too, only if they allow themselves the time and patience to find "the zone" with their partners. Don't trivialize the creative space by gossiping about the latest dramas. I encourage you to leave all conversation outside of rehearsal and don't talk about the rehearsal afterwards, either. There is often an awkward social obligation to talk in rehearsal. I am taking that obligation away from you. You will not be considered rude or antisocial if you only use the playwright's words. This is the single most difficult rule to follow because it takes maturity to trust in someone else's words. You will find rehearsal stays on course, listening deepens to the **kinesthetic** level and meaning becomes crystal-clear.

5. DON'T DIRECT YOUR PARTNER. Hopefully, I have made that nearly impossible for you to do since I am not letting you talk but people find a way to direct their partner. **Never tell another actor what to do, ever**. It's not your place. If you want to direct, take directing. It's insulting and you will offend your partner no matter how nice you seem and how great your intentions might be, so for the better of the work, DO NOT DIRECT.

6. DON'T BURN BRIDGES. You never know whom you will be working with in the future. You might end up auditioning for your partner ten years into the future. Seek a mutual respect and do the work. Sometimes actors equate 'greatness' with 'niceness'. We most definitely need 'nice' people in our lives but when it comes to your scene partner you want someone who challenges you in the scene. The niceties will be done prior to rehearsal in

the prerehearsal meeting but should you not feel compelled to be best friends, it's not the end of the world. Just work together and move on. Chances are if you really do the work you will both have a sense of accomplishment and succeed together. This kind of partnership is a very satisfying connection.

7. GO TO THE SOURCE. If you have a problem with anyone, it's always a good idea to go to the source. If you're having a problem with your partner, then respectfully address it so it doesn't compromise the work. Also, if you have a problem in the scene, go to the source, which is the play. You will always find the answer in the play. It's just a great lesson in problem solving for life. GO TO THE SOURCE.

8. CHOOSE GREAT MATERIAL, BOTH ACTORS MUST BE ACCOUNTABLE. Think of this partnership like a team. If you are given a choice, choose your material together and make sure it interests both of you. Look for plays that will challenge you but are in your age range. Working on a character twenty years older is a lot to ask of you while in basic training. You don't have the tools yet so choose something closer to your age range. Both of you should contribute to the selection process. Also, if there are props and certainly if the props cost money, share the burden. In any great partnership there is compromise. Remember if you succeed, you win together. If you go down, you go down together.

9. PLAY WITH PASSION. Come to rehearsal with energy. Don't waste anyone's time on your personal dramas. Think of this as practice for a job. You would never waltz into work exhausted and apathetic. Bring your best to every rehearsal.

10. NEVER PLAY UNSAFE. Never should either of you ever feel intimidated or unsafe as the actor. NEVER. If you do, then find the easiest, politest way to call off rehearsal and leave. If you are rehearsing late, make sure others are around. Never have a prop that looks real. Never bring a real knife, real drugs, or real booze. This may sound obvious but sometimes actors think 'method' means experiencing the 'real' thing. A real-looking weapon could put someone in harm's way, so choose your props cautiously. We are creating truth on stage through **imaginary** circumstances. If your scene requires nudity and intimacy, make sure you have discussed this with your partner and teacher before rehearsal and do not rehearse nude while rehearsing without a director.

PRE-REHEARSAL MEETING

Sometime before the first rehearsal and while you are both working on your independent homework on the chosen play, schedule a meeting with your partner. It does not have to be more than a half hour. Meet in neutral territory for coffee. If you wish to make it social that is fine, but accomplish the following in your meeting:

1. Schedule rehearsal for the next two weeks.
2. What scene will you be working on from the play? You may want to read a few scene choices out loud together at this meeting. Once the scene is decided, decide what roles you will play. This is the time to read the scene both ways. Reverse the roles to be sure you are not miscasting yourselves.
3. Who will reserve the rehearsal studio?
4. Go over the rehearsal rules together and sign the agreement.
5. Break down the chosen scene into The Rehearsal Roadmap by delineating large changes of action/beat changes.

REHEARSAL AGREEMENT

This agreement lists what you and your partner agree upon for this rehearsal process. You are giving your word that you will commit to the process to the best of your ability in order for both actors to achieve artistic freedom in the rehearsal process. You both want to enter "the zone" so you can reap the fruits of your labor.

After you have read over the Rehearsal Rules and Guidelines, read over the agreement and both of you sign the agreement in each other's books.

> ➤ *I agree to follow the rehearsal rules as suggested in this book.*
> ➤ *I agree to the agreed time allotted for rehearsal and will not stop the process unless it is during a break.*
> ➤ *I will not hold the rehearsal hostage by stopping the process for discussion.*
> ➤ *I will accomplish all the prerehearsal preparation prior to our first rehearsal.*
> ➤ *I will bring all tools, objects necessary for today's rehearsal.*
> ➤ *I will bring my best artistic self to all rehearsals.*

Partner 1

Partner 2

REHEARSAL LOG

Create Rehearsal log to keep track of how you used your time. Your goal should be to maximize your time with your partner and grow with each Zone (rehearsal). This log can help you keep track of your progress. When a scene is presented in class and it is clear, connected, and on the given circumstances, I always ask how much did you rehearse? This can tell me if you're in the zone or not. If it takes two hours for three to five-minute scene that's means you're using your time efficiently. If you spent two hours and couldn't get passed the first few beats with truth and believability, then I can see you're not using your time efficiently. Then I can address which area is unclear. Most of the time students don't fully spend the time in Zone 1. If you don't have an objective or meaning then Zone 2 will be harder. This log is to help you gage how you're using your time.

Date	Time start	End time	Location	Goals achieved	Imple-mented notes	Chal-lenges

TO REHEARSE OR NOT TO REHEARSE...

Students have shared their most common problem in rehearsals is not knowing what to do when their partner continues to want to discuss rather than explore. For this reason, I encourage you to commit to Rule 4, which is the hardest one to follow. Nike made a fortune on it, so *JUST DO IT.*

When actors tell their partner what to do, the relationship is now changed. The moment one person suggests to another the partnership is over. There will be a time to exchange ideas. I am not trying to be a kill-joy over collaboration. There will be opportunity later once skills are more developed.

People talk for many reasons. They talk because they are trying to figure things out. That is what the WALK AND TALK is for. Walk and talk it out as the character. Once you get to workshop your coach will lead discussion.

Michael Chekhov inspired actors to bring their "higher artistic selves" to the acting space. In a sense that is what I am asking you to do: trust that questions will be answered in the doing. Trust that by exploring your questions in rehearsal, they will be answered: Comments like *shall we do that again?* or *do you think your character would say it that way?* destroys the connection you have established, and sabotages creative impulse. Actors must tap into the well of their will. The will is 'to do'. The will is your fire to act. If you have no will, acting will be a very difficult path. It takes immense concentration, so make it easy on each other and keep the focus on your characters and away from the actors. If you both want to have coffee later, then do so, but after rehearsal don't talk about how great you are or how horrible you are. Leave it there. Talk about life. Anything but the work. . . for now.

If there is no will, there is apathy. Work with people who excite you, who light the fire in you. Ideally, your partner can be your muse. Who is the actor in class that everyone wants to work with? There is something quite noticeable behind their eyes. What is it they have? Is it confidence? Depth? Passion? Life experience? If you set up your rehearsals right, you too can develop this confidence, depth, and passion you desire. You will be challenged to challenge others.

I suggest you pair up with someone as close to your skill and commitment level as possible. Choose someone with whom you have chemistry. Not only will it be easier, you will both challenge each other to grow. I know this is challenging because it's always awkward choosing partners, but you are developing interpersonal skills. If you are approached, be open to the possibility and tell them others have approached you, but you would like to meet and discuss possible scenes. Then field your offers. If you receive multiple offers to become a partner, you can line up partners for future scenes. This is great training for your professional career.

If you or your partners are not fulfilling their obligation in rehearsal then both of you are not growing and improving. It takes years to become an actor, so why ever would you waste time *not* preparing? Just convey your message professionally and hopefully it won't happen again. If it does happen again, I advise you contact your teacher together. No one wants to play "he said, she said" so meet together. Most of the time, when students call each other out things change immediately. It seems all the actor has to say to their partner is, *this has happened before and my concern is that it has*

become a pattern; I would like to schedule a meeting with Maria to sort things out. Usually, just by addressing the concern the partnership rarely has to meet with me and the team is back on track and the partner has caught up to speed. It takes a lot of courage to do this but even more to become an actor. These are the first steps on your journey to becoming a professional.

CHOOSING MATERIAL

When you are in training, it's a great idea to work on full length published plays that are very close to who you are. Contemporary American Realism is usually the first genre most teachers begin with. Learning a new process while working on a poorly written script or extremely difficult material will only frustrate you. Choose material you are drawn to.

Don't tolerate indifference when it comes to choosing material. Both partners should bring choices to the table. Many times one actor will take the back seat and expect the more assertive partner to research scenes. You are only as strong as your weakest link.

Lastly, always enjoy what you are doing. Enjoy the material, the process, and your partner. Think about it for a moment. You are in an acting class, learning a craft you love. Not everyone can be an actor. Everyone thinks they can, but you and I know it's a very challenging art. What other profession asks you to bare body and soul, leave your family to go film in distant lands, miss every family gathering when you are in a Broadway show or on tour? We give our souls to this art and most often for not a whole lot of financial compensation in return. So you better love it. Consider this as you now go find your *zone*.

"Boredom in practice comes from lack of engagement."

—Amy Barston (cello teacher)

THE REHEARSAL ROAD MAP

I cannot be false to my sense of truth. . . I can't do it if it offends my sense of truth. . . my anxiety level is enormous, it never gets any less, I learn to perhaps to deal with it differently and understand it better but the fear of creating something is a colossal and very deep fear and if you are wanting to do always your best work so to say, which I don't see any point of spending the time or getting up if it's not going to be my best work, I'm going to be terrified because I don't know what's going to come out. I don't know what's inside me, nobody knows what he or she has to offer until you're in rehearsal and it offers itself. . .

-Estelle Parsons

THE ROAD MAP

Never preplan choices before you go to rehearsal. Once you get to rehearsal you will be armed with the play's specifics, which will serve you in developing your choices off your partner, the environment, and the world of the play.

Channel that inner musician again. The pianist plays both hands separately until they can play both hands together with feeling. They honor dynamics, rhythm, and the notes, written by the composer—but once the music is in their bodies and mind, they don't think about the dynamics or the notes, they just play music.

THE ZONE

Getting in the zone means to:

- Rehearse in character without interruptions or discussion.
- Explore a variety of possibilities using text.
- To rehearse with purpose, applying techniques learned in class.

- To bring your best work to each rehearsal and workshop to maximize growth as an actor.

The Rehearsal Road Map outlines three independent rehearsals and the specific zone goals. It addresses how to achieve these goals with rehearsal techniques and how to support artistic freedom and learning.

By rehearsing in the zone, you will use your instructor's time efficiently so scenes are well prepared for feedback. It's up to your teacher where the workshops fall in your process.

Psychologist Mihaly Csikszentmihalyi defines "being in the zone" as "flow"—a state of heightened focus and blissful immersion.

In his Ted Talk (https://www.ted.com/talks/mihaly_csikszentmihalyi_on_flow) he describes the experience like this:

"There's this focus that, once it becomes intense, leads to a sense of ecstasy, a sense of clarity: you know exactly what you want to do from one moment to the other. . . Sense of time disappears. You forget yourself. You feel part of something larger."

Truth deepens with connection to meaning. Many students run an entire scene without exploring specific moments just to arrive at the "kiss" and believe they are rehearsing effectively. The kiss must be earned as should the scene or it will read shallow and never fully satisfy the audience.

INTANGIBLE TOOLS

Logic will take you from point A to B. Imagination will take you everywhere.

-Albert Einstein

There are three intangible tools an actor must develop. Most important is your **imagination**. Another way imagination is developed is your ability to see yourself in this character, thinking, feeling, and doing from the characters' point of view. Visualize yourself in the place, the environment in the world of the play, and wonder what it must be like to be them. You want to access the imagination you once had when you were a kid but perhaps were chastised for doing so. Daydream on your character.

Characters tell us what they see, hear, believe in as well as their secrets. If actors see what they imagine, then the audience will see it too and feel something deeply. This is when storytelling in the theatre is most compelling an offers an experience unlike any other medium. When the text conjures an image, which collides with the actor's personal past or evokes an imagined picture in the actor's mind's eye, Uta Hagen calls this "inner objects". Inner objects happen if you are connected to the play emotionally and personally, allowing your inner life to deepen on stage through images.

Confidence is silent.

Insecurities are loud

-unknown

Secondly, is your **confidence**. The body and the voice are a give away when an actor lacks faith and confidence in what they are doing. It's difficult to find confidence when insecure voices shut down expression. Every

actor deals with fear, it will always be there but you don't have to bring it in the room. Leave your insecurities, your neuroses outside the threshold of rehearsal. If you find yourself spinning into thoughts of what the teacher wants, or what my scene partner thinks of me, you are concentrating on the wrong thing. Once you have a process, your nerves will subside because your attention will be directed more specifically on the scene and your partner as the other character.

Thirdly, your **curiosity** is an essential element you are expected to bring to the whole process of acting. The need to figure out the character's journey in the play must drive you to do, to uncover, to probe and not to stop until you get *there*. The illusive *there* implies you have arrived. Once you convince yourself you have arrived, you will never grow. So if you know that you never truly *arrive* you will keep searching and remain curious in your craft. Most actors underestimate the depth of the actor's work to find the truth of the character and are often too easily satisfied.

> Curiosity is the lust of the mind
> -Thomas Hobbes
> Philosopher

As Shakespeare's Hamlet says; "The play's the thing…" Sometimes actors can over think things. If you have applied yourself in reading the play, you can enter rehearsal knowing the play will work on you and inspire you. Perhaps it is when we overthink and become too intellectual for our own good, when the acting reads 'academic' or 'disconnected' from partner and truth—that is, when you know you are only in your head and not engaging your body in action to affect your partner.

FEAR

Finally, you have arrived at the first rehearsal. I bet you thought we would never get here. All the work didn't scare you off. That is a great sign. Think of this process as two boxers in a ring. You enter the ring to play, to win. Fight fair. Similar to boxers, you don't have to be polite to each other as the characters but you do have to be respectful and play by the rules. This action alone will set the tone for a healthy creative environment. There is a lot at stake at a sporting event such as boxing. Fighters play to win (objective) and they DO NOT WANT TO LOSE since it can mean life or death. As you enter this match, think of your partner as an opponent. You the character are going to win this round. All plays are built on conflict and conflict means opposing objectives. Don't be afraid to get what you (the character) want and make sure you choose a scene that has conflict.

> Everything you ever wanted is on the other side of fear.
> -Jack Canfield

When in the actors' ring, give it 100% of your effort without force. Remember what Anthony Hopkins said: "You can't act unless you are relaxed". Bring ease and confidence to the ring. Just remember **what is said, cannot be unsaid**. The one element that will help you as you enter this process is "flexibility". Don't get married to a choice right away. Be open to

the possibilities. If your mind says to you, "my character wouldn't do that", prove it by trying it. Sometimes when actors don't converse they still have the conversation in their head. So try it. You never know if a choice works by talking about it. You must try it. Then you will know.

In your pre-rehearsal meeting, one of the tasks is to create The Road Map to your rehearsal. This means delineating the beats. Look at the larger picture. There will be smaller beats and each actor will identify those independently, but for rehearsal purposes go into your rehearsal knowing exactly where one beat ends and the other begins. Similar to the musician who practices music in phrases, this will set up what is called *deliberate practice*. If you and your partner did not complete this task in your meeting, do this before you begin rehearsal in order to more easily find your flow.

Warm-Up
Suggestions

• Meisner
 Repetition

• Imagination
 Exer.: Birth to
 death, Work
 of Art, Shove/
 Hug, Yes/No,
 AG.

• Explore
 emotionally,
 physically,
 and evolve
 into text.

ZONE 1 (ninety minutes)

GOALS

MEANING, OBJECTIVE/OBSTACLES, ACTION

WARM-UP using partner exercises utilized in class.

HOW DO YOU FIND MEANING? Sit across from your partner.

- Observe
- Listen
- Receive

PASS 1 GOAL: MEANING (thirty minutes)

Explore beat 1 and 2

Explore beat 1 and 2

Explore beat 1 and 2

Explore beat 1 and 2

Explore beat 1 and 2

Explore beat 1 and 2

HOW DO I KNOW IT'S WORKING?

- Am I actively listening?
- Are you affecting each other?
- Am I responding?
- Am I on auto pilot?
- Am I stuck in a vocal pattern?
- Am I looking at them or stuck in my script?

If you are still unfamiliar with the lines explore pass 1 again. Move on after you have achieved connection and meaning.

ADD

> Explore beat 3 and 4
>
> Explore beat 3 and 4
>
> Explore beat 3 and 4
>
> Explore beat 3 and 4
>
> Explore beat 3 and 4
>
> Explore beat 3 and 4

LINES TEST: Only use script if you need it. Memorization comes when the lines are the only possible words you can choose to speak at that given moment.

If you're in the zone, Zone 1 should take about 30 minutes Take a pause and study your script independently from your partner. If you don't know what something means, look it up.

PREPARATION FOR PASS 2: Prepare a moment before.

PASS 2 GOAL: EXPLORE OBJECTIVE/OBSTACLES (thirty minutes)

Explore various preparations until objective inspires the scene.

> Explore beats 1–4
>
> Explore beats 1–4
>
> Explore beats 1–4
>
> Explore beats 1–4
>
> Explore beats 1–4
>
> Explore beats 1–4
>
> Explore beats 1–4

MOMENT BEFORE

What did I just do? *Past*

What am I doing now? *Present*

What am I going to do? *Future, which leads you to your objective*

-Uta Hagen's prompts for destination

HOW DO I KNOW IT'S WORKING?

- Is the objective you have chosen revving you up into the scene and helping you invest?
- Does the scene feel too easy?

I want you . .

But . . .

I need you . . .

But . . .

Obstacles give you tension and make it interesting.

Is it too easy?

ADD

- Obstacles: emotional, physical, or environmental.

Explore beats 5 to the end of the scene using Pass 1 and 2 goals. (Meaning, Objective, Obstacles)

PASS 3 GOAL: ACTION (thirty minutes)

What happens when the action changes? The three things that change are: action, rhythm and physicality. Explore where they change in the text and what are choices that embody these changes. Is it a task? A conclusion of a task? A destination to another part of the room out of need? Physical contact with your partner?

Explore beats 1–4

Explore beats 1–4

Explore beats 1–4

Explore beats 1–4

Explore beats 1–4

Explore beats 1–4

Explore beats 1–4

Explore beats 5 to the end.

HOMEWORK BETWEEN REHEARSALS

Reflect on your rehearsal and what you and your partner achieved. If rehearsal flows you must be in the zone. If you are not, reflect why. It might be a good idea to have a conversation with your partner on how you both feel about your rehearsal process. Keep it brief.

Between rehearsals it will be necessary to do your own homework. If you have not had your second read through of the play and the exercise which follows, make sure you prepare this before second rehearsal. Below is additional preparation on relationship and action homework.

RELATIONSHIP HOMEWORK

Bucket of Action

- Berate
- Bully
- Lie
- Seduce
- Amuse

Take the list of verbs garnered from exercises into rehearsal or workshop to give you spontaneous choices if you need them

- How do I feel about my partner? *Love, hate, jealousy, envy. Name every feeling.*
- How do I express these feelings physically?
- BUCKET OF ACTION PREP: What do I do in this play? What do I do to my partner in this play? Gather as many VERBS as possible from the play. Look at Exercise 1 Free Association Write and Exercise 3 Character Narrative. Are there verbs in your writing you used in responding to the play? Place as many verbs inspired by the play on 3 × 5 cards. Bring this comprehensive list to your next rehearsal and or workshop.
- At this point you should be off book for the entire scene.

ZONE 2 (ninety minutes)

GOALS

RELATIONSHIP TO PLACE & PARTNER

In Zone 2, you will explore physical choices in relationship to the place. This concept is what Uta Hagen refers to as *destination*. Destination answers the question what do I do with my body and how do I overcome awkward physicality?

You will also explore relationship to your partner which is expressed physically, emotionally, and through text (action).

PASS 1 GOAL: PLACE (forty-five minutes)

Setting the place in silence. Using the playwright's description of the setting to create the place in which to rehearse. Add furniture and objects which are called for in the script. If the playwright calls for tea or something specific it should be available for you to rehearse with now.

WARM-UP by walking through this set and choosing tasks that could be done in the scene. If it's tea, make tea. If it's coming home from work, explore this. Use your warm-up time with your partner to coexist in this place, imagining what you do here together and physically do it with no words.

At the end of ZONE 1, you explored a physical response to the action change. What do I do in this scene and when with whom? Begin to add this element as you explore the beats. Destination should never compromise your connection to your partner.

You can also explore when you need to look at your partner and when you don't. We often look away when something becomes difficult to say (obstacle). Don't plan, just notice.

Explore destination and relationship to place.

Explore beats 1–4

Explore beats 1–4

Explore beats 1–4

Explore beats 1–4

Explore beats 1–4

Explore beats 1–4

Explore beats 1–4

Explore beats 5 to the end and run the entire scene.

PASS 2 GOAL: PARTNER/RELATIONSHIP (**forty-five minutes**)

Explore the entire scene integrating relationship to place and partner.

- How is your relationship manifesting in the scene? Physically, emotionally, through the text?
- Have you utilized what that the playwright has given you?

PERSONALIZATION: If you're struggling with relationship imagine who might you endow as your partner. Use your imagination to charge your relationship.

CHARACTER HOMEWORK: Up to this point you have approached characterization through identifying with the character. How is the character beyond who you are? What are the character's archetypes, qualities? Explore Character Narrative and expand on this concept bringing character choices that might be different than yourself. Include sensory options you gathered from your scavenger hunt.

ZONE 3 (**ninety minutes**)

GOALS

INVITING CHARACTER

Review notes with your partner and decide on a Road Map to implement notes.

WARM UP: Choose an exercise in Chapter 4 which supports your current challenges.

REVIEW any of the zones if you have lost meaning, objective, obstacle, place, relationship to solve anything that is still unclear.

WHO AM I? Using QUESTIONS THAT BUILD CHARACTER, WALK & TALK with your partner and explore character. Incorporate archetype, quality of movement and other inspiration gathered from homework, readings of the play, and rehearsal. This will look like an improvisational conversation. Prepare this before rehearsal so you maximize time with your partner.

PASS 1 GOAL: WHO AM I?

In this pass of the scene, integrate what you have explored with WALK & TALK.

PASS 2 GOAL: SUBTEXT

In this pass of the scene bring feelings into subtext. You can verbalize subtext which leads to stronger action.

Example of Subtext: *I am over this. You never listen. No. No. No. (actions might be: reject, dismiss, disregard). Never assign an action. Explore. Stay flexible.*

PASS 3 GOAL: INTEGRATION

Run the scene.

If you feel it's necessary, you can discuss the following?

- Did we address the notes?
- Are we listening and playing off one another?
- Are we in our relationship physically, emotionally, and through the text?
- Is our place working for us?
- Are our bodies and voice a conduit for action?
- Are we inviting character?

Did you and your partner achieve your rehearsal goals? Your scene should be ready for your coach to give you final feedback. Live in the now and discover your truth moment to moment.

When Rehearsing in The Zone you can integrate any aspect of training you are learning in class. For example, if you are training in Michael Chekhov technique you may want to explore archetypal gesture in your first rehearsal. At any place in the road map you can add an acting element related to your process. This rehearsal structure is designed to work with any technique and can be used in many ways. I have referenced Uta Hagen's training because this was the heart of my training but your teacher can incorporate other techniques appropriate to their curriculum. The more you know the more possibilities you have to succeed.

ZONE FLOW CHART

The Chart identifies the process. Notice how the arrows are in both directions. This means if necessary return to earlier zones. A productive rehearsal

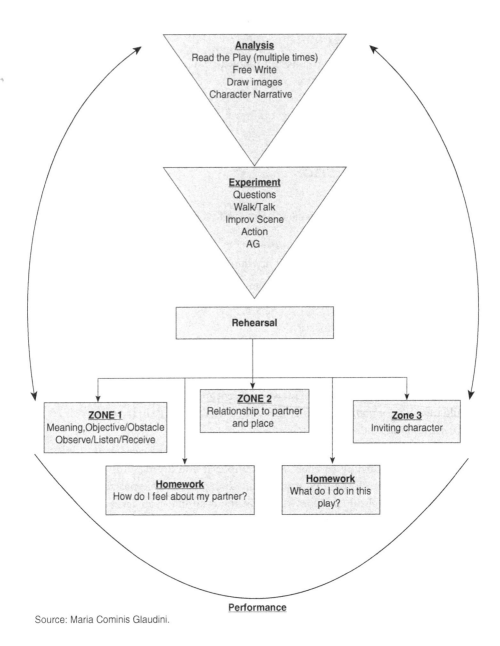

Analysis
Read the Play (multiple times)
Free Write
Draw images
Character Narrative

Experiment
Questions
Walk/Talk
Improv Scene
Action
AG

Rehearsal

ZONE 1
Meaning, Objective/Obstacle
Observe/Listen/Receive

ZONE 2
Relationship to partner
and place

Zone 3
Inviting character

Homework
How do I feel about my partner?

Homework
What do I do in this play?

Performance

Source: Maria Cominis Glaudini.

process requires structure and freedom to choose what needs attention. As you develop skill this will become instinctual. Remember you will have a director but this kind of attention to detail and exploration will serve both actor and director in the process.

OPEN SCENES FOR PRACTICE

Since it's difficult to learn a process and analyze a play at the same time, the Open Scenes provided are to be used as exercises to help you assimilate the rehearsal process first.

Think of the Open Scenes as Etudes. Just as the musician uses short songs to exercise technique, the open scenes will allow you to practice rehearsing effectively. Since Open Scenes are not specific use the suggestions provided to choose your given circumstances. Rehearse the scenes in a variety of ways with varying given circumstances. Once the rehearsal process in learned, utilizing it with a full-length play, along with the acting technique you are studying will make your independent rehearsal more productive.

Who Am I? What do I want? and *What's in my way?* are each actors' individual choices and it is not necessary to share these choices with your partner. These are merely suggestions to get your started without a lengthy discussion.

Write the following suggestions on index cards making three stacks and randomly choose where, when and relationship.

> Silence has a myriad of meanings. In the theater, silence is an absence of words, but never an absence of meaning.
>
> -Sanford Meisner

WHERE

Public Park	Office
Metro Stop in any Metropolitan City.	Living Room
Grocery Store	Bathroom
Bedroom	Outdoors
Kitchen	Public setting
Dressing Room	Private setting
Department Store	Restaurant
	Bar

WHEN

Crack of Dawn	Evening
Early morning	Dusk
Late morning	Shank of the Evening
4:00 p.m. lull	Late night
Dinnertime	Middle of the night

RELATIONSHIP

Lovers or Ex Lovers	Siblings
Roommates	Parent/Child
Spouses	Strangers or acquaintances

OPEN SCENE #1

BY MARIA COMINIS

	A: Hey.
Beat 1	B: Hey?
	A: Hey.
	B: *(Pause)* Hey.
	A: How are you?
	<u>B: Fine.</u>
Beat 2	A: Did you hear…?
	B: About the…
	A: Yeah.
	B: Unbelievable.
	<u>A: Yeah.</u> /*(Pause)* Why… unbelievable?
	B: Well, you know…
Beat 3	A: No. I don't know…
	<u>B: Never mind. I shouldn't have said anything.</u>
	A: Sorry, I mentioned it.
Beat 4	B: It's okay. *(Pause)* Just dealing.
	A: We all are.
	B: Dealing?
	A: Yeah. Dealing, with it.
	B: That's just how it is.
	A: Doesn't have to be.
	B: But…it's…

A: hard?

B: Yeah...

A: We should probably...

Beat 5

B: Right.

A: Hey.

B: Hey.

The following Open Scenes are created to exercise how punctuation can imply subtext and supply practice on stychomithia. Review the box in Chapter 1 "Playwrights Clues about the Character: Punctuation."

OPEN SCENE #2

BY MARIA COMINIS

A: Can you…?

B: What?

A: Give me the…?

B: What?

A: The…

B: What?

A: The…uh… you know.

B: WHAT?

A: That.

B: That?

A: Yeah…

B: Can't you get it?

A: No, I can't.

B: *(Pause)* There.

A: Thanks. *(Pause)* Sorry to DISTURB you.

B: No problem.

A: I mean, I see you are busy. *(Pause)* Very busy.

B: Kind of. *(Pause)* Well…not really.

A: No? Keep on doing what you are doing. Sorry.

B: Don't be. It's okay. *(Pause)*

A: Can you…?

B: What? *(Pause)* OH. Sure.

A: Thanks. *(Pause)* Keep on…

B: Sure.

A: What do you mean?

B: What?

A: SURE?

B: Sure… No problem… It's okay.

A: That's what you say.

B: What?

A: Nothing. I get it. I totally get it now.

OPEN SCENE #3

BY MARIA COMINIS

A: No way!

B: What?

A: NO WAY!

B: No way?

A: NO….WAY!!

B: Why?

A: Because.

B: Because why?

A: Because I said so.

B: Who are you…?

A: Did you really ask me that?

B: YES, I DID.

A: Well!

B: WHO ARE YOU TO TELL ME WHAT TO DO?

A: True. You should know.

B: Don't boss.

A: I'm not.

B: You are.

A: Not.

B: Are.

A: Listen!

B: I'm all ears.

A: LISTEN.

B: WHAT?

A: Really. Listen…

B: I don't hear anything.

A: You don't?

B: No.

A: I need to…

B: What?

A: Go.

B: Why?

A: Just have to.

B: Will?

A: I don't know

B: Can I…?

A: I guess.

B: Tomorrow?

A: Maybe.

B: Maybe.

A: Maybe.

OPEN SCENE #4

BY MARIA COMINIS

A and B are preparing to go somewhere.

A: Are you wearing that?

B: Yup.

A: Okay.

B: What?

A: Nothing.

B: Don't you think…?

A: Totally.

B: What?

A: Works.

B: But you said…

A: I didn't say anything.

B: You did.

A: I asked.

B: Does that mean…?

A: NOTHING.

B: Are you wearing that . . . ?

A: I don't know yet.

B: Well.

A: What?

B: I can't go.

A: Why?

B: I just can't/I decided that I can't go.

A: Because/I just asked.

B: Because . . . because I don't feel like it.

A: That's silly.

B: So call me silly. I'm not going.

A: Come on.

B: No.

A: Really?

B: No.

A: Okay . . .

B: Okay . . .

An awkward pause.

A: Bye.

B: You're going?

A: Yes/I'm going.

B: But I'm not.

A: I got/that

B: But you are.

A: Yeah.

B: You're going/I'm not.

A: Right.

B: Is this okay?

A: Fine.

B: You hate. You hate it when I do that?

A: Do what?

B: You know.

A: I know . . . I just want you say it . . .

There is a knock at the door.

A: Just/a second.

B: Just go.

A: Are you sure.

B: No.

There is another knock at the door.

A: The pressure!

B: I really can't do this anymore.

A: What?

B: Everything.

A: I should/go.

B: Go.

A: So . . .

B: So . . .

Another knock. It's final.

A: Then. That's it.

B: That's it.

A: Bye.

B: Bye.

A: Wait.

B: What?

A: Here. *(A hands B something)*

B: Okay.

A: Wow.

B: What?

A: Okay?

B: I mean . . . what am I . . . you . . .

A: Wow.

B: Are you sure?

A goes to or opens the door.

A: Shall we?

B: We . . .

They end the scene without words.

This Open Scene exercises use of environment, fourth side (wall) and sensory work.

OPEN SCENE #5

BY MARIA COMINIS

A **is seated at a New York City bus stop, eating something.** *B* **enters the bus stop and looks in the direction of the bus and at** *A*, **eating.** *B* **notices** *A*.

A: Twenty!

B: What?

A: I've been waiting twenty.

B: Oh…It's late. Not running on time today?

A: Never runs on time.

B: It must be the…

A: No. It never runs on time. *(Pause).*

B: Yeah…*(B notices A's food).*

A: What are you looking at?

B: Nothing.

A: No. Not nothing.

B: I don't know. I'm just waiting.

A: I wasn't being confrontational.

B: I didn't think you were.

A: Why do people always stand when you can sit?

B: Well, I don't want to crowd you. You seem…

A: Sit.

B: No Thank You.

A: SIT!

B: NO. Thank You.

A: You afraid…?

B: Afraid? *(B laughs)* NO! *(Pause).*

A: You should be. It's New York City. *(Pause. B takes a seat).*

A: You want some?

B: No. I'm good.

A: I've been waiting twenty.

B: So you said.

A: Twenty. Twenty. Twenty.

B: Is that it? I think it's coming. *(They look and move in the direction of the bus)*

A: It always does that… seems like it's…

B: But… wait…

A: (Laughs). Oops.

B: Damn.

A: You visiting?

B: No.

A: You live here?

B: I do.

A: Not long.

B: How can…?

A: I can tell. Where you heading?

B: To work.

A: What do you do?

B: I am sort of…

A: You a banker?

B: No.

A: An actor?

B: No.

A: A…

B: What do YOU DO?

A: Me?

B: Yeah.

A: Oh… I'm kind of in between gigs right now.

B: Yeah?

A: Unemployed as they say.

B: Well, I will be soon if I don't get to work.

A: Fastest mode of transportation in Manhattan *(Refers to B's feet)*.

B: Yeah. I guess I better move along if I'm gonna… You? Hey should we grab a… *(Pause)*.

A: I'll wait for the next one.

B: Looks like you might be waiting all day.

A: All day, all month, all… *(Pause).*

B: You need this… it looks like... *(B hands A something).*

A: Okay…

B: Okay.

(A remains, B exits).

WHAT AM I LOOKING FOR?

Listen to that voice of satisfaction. Everyone's voice has a different threshold. **The answer is in your partner.** If you have affected them, it's working. If it stops working, then change it. Remember, don't try and replicate the line delivery—that is repeating for a result. Find the need to speak and then you will use the language as your weapon (**action**) to get what you want. Your first rehearsal may feel awkward, but as you sink deeper into rehearsal you may find yourself intently focused and unaware of anything else but your partner and the world of the play you are creating. This means you are now rehearsing in *the zone*. Never plan a choice but explore what choices are possible in the moment to moment experience.

SETTING THE SET

Activate your imagination for the setting at the bus stop in Open Scene #5. What does a New York City bus stop look like? What stop are you at? Are you uptown, downtown, midtown, east side, or west side? What does it smell like? What surrounds you? What do you do here? Keep in mind the tasks, behavior, relationships that exist to people, places, and things. Look for a clear playing area and space between objects and balance on stage.

Setting up all four sides might take a few words. Establish entrances, exits, and what might be on the fourth side. You can say out loud: bagels shop, median with bench, trash can, bus schedule sign, traffic light. Take turns sharing what you might see on the fourth side: "I see. . ." Use the playwrights world and your imagination to fill that fourth side with images so if you need to, you have shared the fourth side as part of your shared world in the play. The goal is to set up fertile ground for behavior and imagination. Both of you will begin to develop a relationship to the place, environment, atmosphere, and the world you are creating. If you find you want to disagree then stop and just begin rehearsing. Move on. Any glimpses of "actor conflict" will destroy your creative environment cold. Keep the conflict between the characters. It's not worth sabotaging a whole rehearsal over whether the window is SL or SR. Always go to the play to lead you

to the answer. The energy you set up will influence how much you get accomplished.

Once your place is set up, cross to the peripheral of the threshold and stand at opposite corners. Take a moment to take your place in. Take your partner in. Be outside of the space before you enter it. Cross the threshold into your set and in silence, walk the space. As you walk, allow this space to become the world of the play.

See, hear, taste, smell, and touch. Explore where you go, what you do here together. How the characters behave in this place together. Is this mutual territory or does one of you occupy the space and the other frequent it? Endow the space.[1] Sometimes objects come to mind when you enter the space. If the playing area is cluttered, open it up. If you have too many objects and they are not being used, strike unnecessary objects. A cluttered space will not help your acting. Objects occupy space and energy. Allow the space to breathe so there is a playing area for the chemistry between you and your partner.

[1] Hagen uses the term *endowment* to identify qualities to a person, place, or thing that is does not have. Using the imagination, I endow the place as a New York subway; I frequented every day for ten years.

CHAPTER 4

EXERCISES & SOLUTIONS

Creativity is allowing yourself to make mistakes. Art is knowing which ones to keep.

-Scott Adams

ACCEPTING CRITICISM

If you and your partner were able to find your zone than you probably feel more than prepared to present your scene for feedback. When you work on full-length scenes I suggest you present only the sections which are prepared. This way your getting in the habit of sharing your best and identifying where you are in development.

When you are presenting for a workshop, I advise students to have someone in the class take your notes down, verbatim. This way you can focus on being in the moment with your partner and the details of the notes are in your notebook for your next rehearsal. This will also allow you to be fully present for your coach. Dr. Betty Ciuchta, D.C., has always said "Nothing is received when it's met up with resistance". Learning how to receive criticism without resisting will be of great importance to you. Feedback is the only way you can grow. Then you know what to work on. If you have a problem receiving criticism you may want to work on this because life as an actor will always be judged, critiqued and reviewed.

Students will often repeat the same mistakes. Either you are not listening to the note the first time, or you disagree with the note, or you don't know how to implement the note.

While you are playing the scene, live it, breathe it and by all means do not watch yourself. After the scene, objectify your work. Assess it honestly. Ask yourselves: what was not clear in my work? It's important because *everyone* will have an opinion. *I wasn't fully pursuing my objective.*

I was not fully in the moment; I started performing when I heard the laughs. Self-evaluation and objectivity will serve you well for the future.

NEED TO SPEAK/MEMORIZATION

There is often a differing of opinion when actors should be fully memorized. For television and film, it differs. The main difference between theatre and television is the rehearsal process.

In television, there is none. In theatre, rehearsal periods are reduced due to budget cuts. Some directors will require actors to come to the first rehearsal, off book. In television/film auditions, it is an industry standard that actors come into the audition, camera ready.

When a director asks you to come in memorized, you have an obligation to give them what they want. They are saying to you, they want to get into exploration with you, immediately. Here are some specific ways to memorize lines or at least almost know them without attaching a cadence or being locked into a delivery.

INDEPENDENT REHEARSAL BEFORE REHEARSAL STARTS

I would find a friend and have them help you explore the scene with you using Zone 1 goals. Keep in mind, this is exploration. Nothing is set until you work with your director and cast.

MNEMONIC DEVICE

My former student Keiko shared this memorization exercise used in teaching public speaking.

Write the first letter of every word AND the punctuation. If the line is "Speak the speech, I pray you, as I pronounced it to you trippingly on the tongue," the letters and punctuation would be:

$$S\,t\,s,\,I\,p\,y,\,a\,I\,p\,i\,t\,y\,t\,o\,t\,t$$

To add to this, I suggest, write the *other* character's entire line. This way you're learning cues as deeply as your own lines, helping you discover the need to speak.

PSYCHOPHYSICAL

Walking and talking while learning lines can help integration between mind/body. It's instinctual, because the body is deeply connected to action. Utilizing beat changes, notice the shifts in your body. Never "block" yourself only explore how your body responds to those changes of action.

LEARN BY ROTE

Another process is to learn the lines by rote without any meaning or connection attached. Some actors find this process works for them. However,

learn the lines exactly as written. Word perfect. No paraphrasing. Use punctuation. Some will advise that in television it does not matter and that they want you to paraphrase. Only do this if the casting director or director tells you to. Most of the time the writer wants to hear his/her words as written to see if it reads true.

GUIDED DISCUSSION

Perhaps there are some brewing questions that have gone unanswered. Below are questions to spark a **guided discussion**. DO NOT TELL YOUR PARTNER WHAT TO DO. You will destroy every ounce of trust you have built so far. DO NOT REVEAL CHARACTER'S SECRETS.

> Does our set work? Are we invested in our place? What could we add that might help? What might we take away? Do we have a reference for the rest of the place/world? Are we missing essential objects?

> What are the specifics of our relationship? If we are married or intimate, what are the details? Discuss only what is absolutely necessary.

RELATIONSHIP EXERCISES

Take those feelings you have about your partner's character, which you explored in your homework and now explore the following:

How do I feel about you? What do I do to you because I feel . . . ?

First make a list of feelings that your partner evokes from you. You can write them or remember them. Physically express these feelings to your partner and they will physically express their feeling back to you. Once someone initiates a physical gesture this exercise becomes a nonverbal conversation driven by feelings and actions. You also may move, walk around. Once you begin to feel the bodies are connecting, expressing feelings through action then integrate text.

WORK OF ART

Theatre requires intimate connections but it is imperative that you respect each person's personal boundaries. Have a conversation of what those boundaries are.

We are in a gallery. Look at each other and imagine your partner is a work of art. Everything around you is full of history, meaning, and beauty. Observe. Really study this work of art. Its shape and texture. See the details. Watch the subtle movement as it breathes. Begin to touch the artwork slowly with respect. Hands, arms, face, knees back, belly, and face. Find the

pulse on the wrist or the neck. Work from top of the body to lower extremities and back up. What intrigues you? Where did this art come from and what has it been through? Allow yourself to be curious and imagine on this art. Once you have taken in the artwork, change and allow your partner to see you as a piece of art.

THERE WAS A MAN/THERE WAS A WOMAN EXERCISE

As you begin to work on characters that are farther away from who you are, your life experience might not fully serve you quite yet, so trust upon your imagination. This exercise originates from what has been called the *hot seat* or *the interview*. My colleague Ragnar Freidank inspired a fresh take on an old exercise in a Michael Chekhov (MICHA) workshop. It is an imaginative way to access the character indirectly. I have narrowed it down to partners so you can play off of one another, building a relationship as well as finding more information about your characters. I call it: *There was a man, there was a woman.*

The scene partners go on stage and sit in chairs four feet apart, facing the audience.

Assign two colleagues, one for each, to write what they say, verbatim. Dim the house lights. Add stage lights. Alternating, the actors finish the sentence out loud, "There was a man…" or "There was a woman…" They are talking about the characters they are playing. This exercise takes time and the teacher can prompt the next step after changes take place. Explain as little as possible before the exercise begins. It takes a while for the actors to reach *the zone* but when they begin to enter it, it is noticeable. A level of concentration begins to change. After a few minutes or so you can invite the actors to turn their focus to each other, should they feel the impulse. Then after a while, the teacher can invite the actors to stand and/or make physical contact should they feel the impulse, always allowing the exercise to evolve spontaneously. If the actors are trained in understanding form (beginnings, middle, and ends), they will sense an ending. It is a richly, satisfying experience where the actors experience the characters' depth first-hand. The student audience can see before their eyes the shift as the actors and the characters emerge. If you decide to try this exercise in your next rehearsal, record it on your phones and transcribe it later. The information you gain will provide you with tremendous insights to your characters' point of view.

THE MOMENT BEFORE

You appear like you are coming from the wings, not from the world of the play. There was no preparation. How do you prepare for the moment before you enter the stage as our character? The given circumstances must influence your entrance. To crystallize the preceding circumstances, Hagen gives three questions that will anchor the character's truth, here and now. The example below are possible choices for Character *B's* entrance in Open Scene #5.

> ‣ What did I just do? (Past) *I just came from the airport after spending two weeks in sunny Southern California. The LIR was packed. My jacket smells like Indian food from dinner the night before. I just carried my heavy suitcase up the crowded subway stairs in 100% humidity.*

> ‣ What am I doing now? (Present, as I enter the stage/bus stop near, Penn Station) *Putting metro card in my pocket and picking up my bags as I dodge a homeless man on the stairs asking me for money. I give him change from my pocket. It smells musty and it has been raining. Looking for a bench to sit down to regroup before the last mile of the schlep to work after flying all night.*

> ‣ What am I going to do? (Future. Objective.) *Keep to myself so I don't have any more pressures to give away the last five dollars left in my wallet. Dig for a snack and water in my bag and ponder where I might go to dinner and with whom, later this evening.*

THE OBJECTIVE WORKSHEET

Finding the objective at the start of the scene is crucial. The OBJECTIVE WORKSHEET can help you troubleshoot if you're having a hard time finding your objective. In the worksheet below you can source where you found the information in the script.

What do I do in this play?

What do I want in this play?

> Love/Joy/Passion
> Wealth
> Power
> Security
> Fame/Notoriety
> Power
> Acceptance/Validation
> Peace
> Balance
> Self-worth
> Purpose/Fulfillment
> Freedom
> Justice

What do I do in each scene?

What do I want in the scene? Does it change? What does it change to?

What gets in my way of my WANT?

Emotions

Physical discomfort

Weather

Another person

Danger

What I may lose if I don't get what I want

ACTION & ARCHETYPAL GESTURE

Michael Chekhov[1] utilized archetypal gestures to initiate actions. They are *push, pull, reach, throw, gather, lift, smash, twist and tear.*

When the mind doesn't know, the body can often tell you. Here is an example of this: Extend your arms with energy and *reach* with both hands for your partner. Allow the arms to open so your heart is open to sending the gesture. Notice reaching is endless. It is often unsatisfying. In a way, it is incomplete. Stay in reach for at least a minute. Once something begins to happen inside you, connect it to the text and send to your partner. After exploring the archetypal gesture of *reach*, internalize the gesture. Once it is fully internalized, you can explore *reach* with text, letting go of the outward gesture. Then the archetypal gesture, *reach*, is crystallized psychophysically within you and connected to text but the body is free to behave. Does the archetypal gesture *reach* conjure up an action (verb) inside of you? *Reach* can feel needy and the action initiated might be *to please.* You can explore all the gestures and see what the body evokes the mind to do. You can see how the archetypal gestures can open a pathway to clearer actions that engage body *and* mind. Incorporating archetypal gestures in your rehearsal can help you express action more physically. It can be used in beat-to-beat rehearsing to find the clarity of the moment. I have found this exploration a lot more effective then talking about the problem in a circuitous discussion. You can get even more specific of where you gather your energy. Gather the energy from one of your centers (head, heart, or pelvis) and send any archetypal gesture to your partner. By initiating direct action towards your partner with a specific energy center, you might also awaken the chemistry between you.

THERE IS NO LIFE

Sometimes actors get stuck and forget to engage in behavior and life. If the playwright has not provided an activity within the given circumstances, then it is your job to create one that supports the given circumstances. Sometimes actors have not read the play carefully enough to notice the playwright has given them a task within the given circumstances that is very specific. Don't ignore it. Use it. Perhaps wine is added to the scene or a meal is being prepared. These activities give the character life and destination (Hagen). In Beth Henley's play *Crimes of the Heart*, the character of Babe makes lemonade throughout the play. This is a profound ritual for this character since her life is a tragic mess but the playwright gives this

[1] Michael Chekhov was nominated for a Best Supporting Actor in Hitchcock's film Spellbound, he was a Hollywood acting coach to the stars and Stanislavski's star student.

character a beautiful coping device, which makes the audience love her. As an actor, seize these clues—it will define who you are.

Always integrate new choices in your rehearsal first, before you present it to the class. New things will happen in live theatre but it's never wise to wing a choice that will require rehearsal. Inside the characters' destination you can explore indirect action. It is helpful, since sometimes when actors are involved in a task they get distracted. Keep pursuing your objective even if you are in destination. We do this in life all the time. Characters don't stare at each other all the time. They live; they behave and select the significant moments to engage eye-to-eye. When playing too generally, actors sometimes make the mistake of getting in each other's face, which breaks the tension. I have often heard it said, *"If you get that close to someone on stage you are either going to kiss them or slap them."*[2]

WHERE'S THE HEAT?

Too much heat is a fun problem to have. This is when the play suffers because the actors are crazy for each other and they can't focus on the play. Or, the more common problem for students is no chemistry at all. There are a few ways to ignite the chemistry between actors. One solution is to endow your scene partner as if they are someone you are crazy for. You endow them with qualities of your imagined partner. Or another solution is to seek something interesting about your partner and focus on it. Overlook the qualities that you dislike in your partner; focus on the qualities that are interesting and expand on them. For example, perhaps your partner has incredibly soulful eyes. You can see the pain, their vulnerability way behind the surface of their eyes. You can obsess over their eyes, studying them with every detail. Pretty soon they will feel a connection and will begin to reciprocate it. If the two suggestions don't work, then you can suggest the following exercise to connect.

AWAKEN YOUR CENTERS

Stand two feet away from your partner and focus on engaging your center to their center. Allow three inhalations and exhalations for each line of connection: the heart, the head, and the pelvis. Receive their exhale on your inhale and vice versa. It might get uncomfortable. Allow it to be. Once you feel the heat, take it right into the scene. Don't destroy it by commenting on it.

[2] This is one of those comments that has been passed down for years by acting teachers and directors. I believe it can be traced to HB Studio Artistic Director Herbert Bergof, who was a charter member of The Actors Studio and Uta Hagen's husband.

When you experience the lack of chemistry, you can see why directors cast actors who have a natural connection. When time is money, there is no time to be working on chemistry. However, in school and in training this is a very real problem.

What about when you have too much heat? Keep your head in the game and remember that the play is the *thing*. We should all be so lucky to have such problems.

IMPROVISATION

Improvisation can be a great way to find new things about the character you never would have imagined. When I say improvisation, I don't mean improvisational games. Those have their purpose, but for our purposes we will use the structure of improvisation as a means to access character, new information, and discovery. Sometimes you just don't know what is wrong with a scene. You may not identify with the character; you may be bored; you may be anticipating. Improvisation is a tool to free you from the ruts you may find yourself in. Each improvisation will have three rounds. Each round the time will decrease. The varying times help you not to indulge and select pertinent choices while training you in form (beginning, middle, and end).[3] The time frame will help you to stay in your body with your partner and help you to not overthink.

Events are things that happen in a play

My colleague, Russian/American Actress and Professor Svetlana Efremova-Reed, on identifying a character's event; *Event is not an ordinary fact; it's a leading circumstance of the scene, and of the play. Something that changes the action, changes the objective and it's extremely important. Examples that are obvious are: birth, divorce, a fire, losing a job, we understand those. Let's say you cooked a turkey, and you burned the turkey, is that an event? No it's not. If it's an ordinary day and not really important, it's not an event but if you are dating a man and it's your last chance to get married and you want to impress him, and show what a great cook you are and you put the turkey in the oven and then you BURNED it, now THAT IS AN EVENT.*[4] An **event** requires the actor to process extraordinary information, which changes their action.

IMPROVISATION #1 EVENT: Choose an event in the scene that you have not fully discovered: perhaps you discover your lover is having an affair.

[3] Form is one of Michael Chekhov's four brothers in art. He suggests that these four elements are inherent in all art. The others are: ease, feeling of the whole, and beauty. Chekhov, Michael. *To The Actor: On the Technique of Acting.* 1953. New York: Routledge-Simon Callow, 2002. Print.

[4] Svetlana Efremova-Reed has served as a Head of Acting at California State University Fullerton for years. She received her MFA from Yale School of Drama and BFA from St. Petersburg Academy with numerous theatre, film and television credits to her name.

ROUND I: Set the timer for 5 minutes. Use the timer as a marker to begin to search for an ending. Don't kill it by suddenly stopping the improvisation. Finesse your ending. Search for it. Find an artful way to end the moments explored.

ROUND II: Take a few moments to reset the timer and do the improvisation again, but in half the time. Again when the timer goes off, finesse the ending.

ROUND III: Now do the improvisation in one minute and finesse the ending.

You can also explore improvisation on *relationship* and *environment* in the same way. Perhaps the relationship lacks intimacy. Find a moment in the play to explore and go through the rounds the same way. On exploring environment, you and your partner might try an improvisation of waking up in the morning or coming home at the end of the day. Three timed rounds gives you structure and time to explore with a framework attached so no one is leading and no one is following.

You actually may find important moments of the scene you had not discovered before. Then go back and play the scene and see what happens.

SHOVE/HUG EXERCISE

There are times when you and your partner will need to stop being polite to each other in the scene. You will be holding back and will need to break through inhibitions to get to that ugly, nasty side of yourselves. It may just be you need to get more active and alive. Push your partner either at the shoulders or the back. Challenge them physically. Do not hurt or harm, just push enough to awaken their senses. Watch what happens. This exercise initiates permission to NOT be polite. The actual physical contact wakes you both up. The moment of contact is the most interesting. Watch the response in your partner's eyes. Something most definitely will happen. Once you have a physical exchange then integrate text. Some people don't like this exercise but I think it's a great way to say *I challenge you to truth*. No one should ever be in pain, but if you get a bit irritated or mad, it's going well.

On the other side of this is when you feel like your partner is not taking care of you on stage, ignoring, oblivious; go to them and gently hug them, or gently touch them appropriately. In every relationship there is love or it's not worth fighting for. Hopefully, they will get the message that you need some attention. Ms. Hagen used to say, *if you want your partner to give you more, then give them more*. By the power of touch, we affect our partner – move them or irritate them. Hopefully this will change them. It might soften them or, it might bring more conflict to the scene.

TROUBLESHOOTING

Sometimes I hear actors say: *I just don't know what Maria wants from me.* Their objective is clearly *to please the teacher*, and they are not focused on their work. Instead, please the other character. Want something from them. Need a reaction from them. Engage your sensations and your imagination.

Sometimes even though actors do the work there may be elements to the process you are missing. It usually means you're ready for feedback. Let it go knowing you have done your best. Keep in mind this work is never finite. You are a living breathing entity, and because we are not robots it will always change.

Inspire the scene with a gift that serves the scene. It can be music, the character's favorite food. Make sure whatever you choose is on circumstances and it's given at the rehearsal as the character to the other character. This can initiate new feelings in the character's relationship. I remember a time when students were working on Cindy Johnson's *The Person I Once Was:* the actor who played Blaise brought a box of See's chocolates to rehearsal, since in the scene the hot object[5] is a box of chocolates for Mattie. The actress was delightfully surprised in the moment and she was able to use it thereafter. The box was wrapped so beautifully and there was real excitement in opening it each time. It sure beat the stale dollar store candy they were using before. Delight, surprise, and generate joy and you will find the sparks between you.

If you feel physically stifled, change the set up. Add or subtract objects. Reverse your set. Change the clothing of the character. Make sure you are revisiting the play often.

What if my partner and I are getting the same note over and over? Then you probably didn't listen the first time the note was given. If every acting teacher had a penny for every time we gave the note "You are not playing your objective strong enough", we would be rich. Here is a familiar scene.

TEACHER: What *is* your objective?

STUDENT: (blank stare) I want her to understand me.

TEACHER: How would she behave if she understood you? What would that objective look like, if you got it?

STUDENT: She would listen to me and talk with me.

[5] A hot object is an object the playwright plants in the given circumstances. It usually has emotional significance and helps to drive the scene and the relationship. (Hagen)

TEACHER: Well, isn't she doing that? She is in the room. She hasn't left. You have understanding so you can't fight for something you already have.

STUDENT: I want her to forgive me.

TEACHER: Now that is something to fight for. How?

STUDENT: Treat her lovingly, tell her "I am sorry."

TEACHER: More active. What do we do when we have really messed up?

STUDENT: Apologize.

TEACHER: More.

STUDENT: Beg.

TEACHER: MORE!

STUDENT: GROVEL.

TEACHER: YES! HOW?

STUDENT: I could pour her some tea and offer her something, behave like I actually like her.

TEACHER: Let's see it.

I am sure this is all too familiar. *What do you do to get what you want?* I often hear: *I want to explain to her that I love her.* Explaining is a given, if you have lines you are explaining. Explaining is not a playable action. Actions must be physical, visceral, and emotional and make your partner do or feel. Actors are often hard-pressed to come up with active verbs. Sometimes actors settle with the first choice. Dig deeper into yourselves. There is always more there. Go beneath the surface.

Have you watched amazing artists dig further into themselves for this kind of depth? It is palpable. It is sometimes hard to see it in great actors because great actors don't show their work. We rarely get the opportunity to see the transition from actor to character. This is a good thing, but it's really fascinating to watch and sometimes easier to notice in other artists. Recently, I had the amazing pleasure to watch Gustavo Dudamil conduct the LA Philharmonic up close on camera. It seemed he was unaware, the camera had captured him in a most telling, artistic, private moment. Watching him between the movements is a lesson in acting. He would shift from the ending of the last movement of music to neutral with an exhale, then he would find in him a different energy, as if it was a whole new character initiating the next movement of music, his whole being changed with tempo, energy, and passion. It was truly inspiring. Great actors do this but they don't show it—that is why they are great.

ONE FRY AT A TIME

Students share they often struggle with getting started. That is the hardest part of any work. They want to prepare, they know how to prepare but some force holds them hostage to their process.

Mel Robbins, CNN spokesperson and author of *The Five Second Rule: Transform Your Life, Work and Confidence with Everyday Courage*, suggests it's because our brains are wired to avoid something challenging. Her research shows three things can paralyze us from change. They are (1) The Brain, (2) Fear, and (3) Success. Our brains are perfectly happy with ease and comfort but if the decision to do something is made within five seconds of the impulse, it can have the potential to change your life.

Your friend suggests you read a new play that you're perfect for. You get distracted and decide to follow through later. A week later, you're called to audition for a replacement role in that same play and the director knows your work but the audition is tomorrow. If only you had gotten the play, checked it out, worked on it when the universe dropped you a clue, you would be ready for this opportunity? Woulda, shoulda, coulda. That's a familiar story for so many. Those individuals who acted upon their impulse and we know them, are starting rehearsal the day after tomorrow. A lot can be gained by the five second rule if we practice it.

Robbins research shows the brain makes an imprint when the desire for a new achievement is followed by a physical action within five seconds. There is a magic window of opportunity provided by your frontal cortex where the short-term memory exists to act. After five seconds that window closes and the impulse is forgotten.

You may have an impulse to make a choice in rehearsal but something stopped you from doing so. The stop sign could be yourself saying, "my character wouldn't do that" or your partner could stop the flow by talking to you. Robbin says, "The 5 Second Rule is about listening to the Language of the Soul . . ." which is our desires and deep connected impulses toward change. This skill is not only valuable in rehearsals but also in life.

So, what is the problem? Why didn't you rehearse? *I didn't have the time, I couldn't focus and I thought acting was fun, not work, my partner is not . . .*

College students are spread thin, working, academic load, their social life, individual practice as well as rehearsals. Students often share there isn't enough time in the day to do everything. They are overwhelmed and overcommitted.

Cassie O. shared, she asked herself, "What can I remove to make more time for rehearsal and homework?" She shared she eliminated distractions, the people who suck up her time, and energy including meaningless scrolling and trolling because maybe you're lonely or bored.

Carly M. said when she's overwhelmed she doesn't want to do anything. As she was enjoying her guilty pleasure she had an epiphany. *One Fry at a time!* That's it. She eats her fries one at a time and enjoys every fry, realizing if she could only do this with her practice, homework, and obligations, they would disappear.

Some students say the paralysis comes from the negative chatter in their brain. It's the voices that say, *you can't act. You will never succeed. Everyone wants to be an actor* or other self-sabotage talk that is toxic and prevents you from achieving your goals. Some say they are unfocused because they worry about what I will say.

Sarah B. said to help her focus she is proactive about receiving criticism. She makes three columns. One column is the teacher's feedback, another is her own feedback, and last, her strengths as she sees them. Objectifying criticism helps her from feeling like it is a personal attack. She values her own assessment of the work as well as her teacher's but it is put into perspective.

Our thoughts can play havoc with our success. If you can take action starting with *one fry* when the impulse comes, the mind will follow and pretty soon you will find yourself in the zone and achieving your best.

"Performance is an act of faith."

—Marya Mannes

FROM ZONE TO PERFORMANCE

Keep the channel open. No artist is pleased; there is only a divine dissatisfaction that keeps us marching and more alive than others.

—Martha Graham

A master teacher told my son when learning new piano repertoire to learn new pieces with articulation. Learning the scene with the "playwright's articulation" deepens your connection to it. This is what Angela Duckworth refers to as *Deliberate Practice* in her book GRIT: THE POWER OF PASSION AND PERAVERANCE.

Duckworth's basic science of *Deliberate Practice* is:

➤ *A clearly defined stretch goal*

➤ *Full Concentration and effort*

➤ *Immediate and informative feedback*

➤ *Repetition with reflection and refinement*

Working on parts of the whole that's difficult or not understood yet means rehearsal will require failure to achieve. This is often tedious. Duckworth tells the story of the baby learning to stand then walk. If you watch the baby as they fall there is no judgment. Toddlers are willful to learn this skill. They fall. They get up. She says that it is not until kindergarten where adults react to the child's mistakes, which causes this feeling of failure.

Duckworth also suggests success happens when *Deliberate Practice* is a habit. "It's all about in-the-moment self-awareness without judgement." It's about relieving yourself of the judgement that gets in the way of enjoying the challenge.[1] When experts practice deliberately they find flow and flow inevitably leads to joy.[2] The actor's life is perpetually judged,

[1] Duckworth, Angela Grit. *The Power of Passion and Perseverance* loc 2047.

[2] Duckworth, Angela Grit. *The Power of Passion and Perseverance*.

critiqued, and reviewed but our biggest critic is ourselves. Being objective about your work perpetuates growth. We are not the work. The work is what we love to do.

When the elements of a project or play come together, there is excitement in sharing it. Whether it is a scene, a project, or an opening night, the energy emerging from the dark, empty seats now filled with people, lives, experiences can impact nerves, and cause performance anxiety.

If you allow them, nerves can derail your performance. You might be thrown by unexpected laughter or a deafening silence. You might be tempted to push or play for laughs. You might know who is in the audience that night and want to impress rather than trust yourself. You might be auditioning in front of the creative team of a Broadway show and your future will depend on this audition. Experts draw on technique, preparation, and trust what is gained in *deliberate practice*, which allows nerves to be channeled into energy and excitement.

OPENING NIGHT & BEYOND

Michael Chekhov (Micha) when playing Hamlet, for which he received much acclaim could detect who was in the audience by how they responded. If it was doctors or teachers or businessmen out there, he could tell. He could read the audience by what they responded to and adjusted instinctually.

> No work of art is every finished, nothing is ever static, no performance is for keeps.
>
> -Uta Hagen

The audience is the last, most important piece of the storytelling event, and ultimately the reason why we do it. Art is meant to be shared and has potential to make a lasting impression on the people you share it with. Remember the audience is new to this story. They haven't been with the play for the last few months at rehearsal. Performance will teach you how to be attentive to an audience and sensitive to what they are and are not getting. Your director will guide you through previews on how to clarify the storytelling so it's compelling and clear. There is a learning curve to performances. Each audience deserves your full commitment. Never blame them. Help them by being attentive and with experience you will know how to adjust to keep them engaged.

REJECTION

You've been cast. You're well into the run of a show. Your friends come to see you. The show went well. You got on top of your nerves and you feel good about your work. It's time to see your friends and family backstage after the show. Everyone must deal with this awkward moment so we may as well talk about it openly. Not everyone is going to like your work. Art is subjective. Aesthetic is subjective. Does it hurt when this happens?

Of course. It's human nature to want acceptance but if you let validation define you, you will never get out of bed in the morning. Needing validation will prevent you from taking risks.

Taking risks starts in class. Students avoid taking risks and hold tight to their comfort zone. Why? Fear? Rejection? I'm one of those teachers that if you're not off to a bold start, I will stop you. I know. It's annoying. Why waste time? Students sometimes can't get passed the first two lines and I stop them. I can see their faces before I even open my mouth, they get flushed, irritated with me, and their subtext is almost audible.

I never can get passed the first two beats with her. I suck. She hates me. I should just give up acting all together.

I give some direction which is clearly not heard because their subtext is so loud they can't hear me over their "shit chatter."

Yea. See. I knew she hated me. She hates me. I suck.

One day in class, we were talking about this negative self-talk and I accidently said "shit" instead of "chit" and now the term has been coined "shit chatter" by my students. It's the negative, low self-worth voice that bogs your creativity down and stops you from growing. Everyone can hear it in their heads but the actor's job is to replace their own subtext with the characters.

I have also seen students use rejection as fuel to empower them. If you're an actor to your core, nothing will stop you. Nothing. And rejection is your daily bread. It feeds you. Gary Perez, actor/coach tells actors to book the room instead of the job. What this means is go do your work, be specific, be the best actor you are and walk out confidently. Is this the only job they will be casting? If you don't book this job but book the room, you will be remembered and called in again.

When choosing a life as an actor you understand there will be many a "no" before the "yes." Not everyone will respond to you and your work. Ultimately, what defines a career is the faith you put into your process, the joy you get from sharing your work and the deep connections made that last a lifetime.

Bryan Cranston, award-winning actor, gives great advice: *Know what your job is. An actor is supposed to create a compelling interesting character that serves the text and present it . . . and then you walk way. And that's it. Everything else is out of your control. And there is power in that. And confidence in that . . . once I adopted that philosophy, I never looked back and I have never been busier in my life . . . Good Luck.*

"The knowledge that every day there is something more to learn, something higher to reach for, something new to make for others, makes each day infinitely precious."

—Uta Hagen

Part II The Profession

After fully investing into the actor's rehearsal process, you may have a whole new appreciation for what you signed up for. Becoming an actor will forever be a balance between craft and commerce. The first part of this book deals with your craft.

Part II will address how your craft fits into commerce. It will specifically address professional protocol, professional relationships, and end with the professional's perspective (interviews).

Once students obtain fundamentals in the acting process they have a new appreciation for the actor's responsibility as a career and a fundamental knowledge of professional expectations are helpful at this point. Your work ethic and professional behavior will inform your future endeavors and make an impact on employment.

"Be so good they can't ignore you."

—Steve Martin

CHAPTER 6

PROFESSIONAL PROTOCOL

The incessant drive and belief, is what I think makes you rise above the noise...

-Jon Hamm

W hat exactly is the noise? The noise is the chaos, the politics of the business, professional jealousies, competition, the things you can't control. There is so much information no one tells young actors that you're supposed to know and it's important to know that it changes and will change by the time of this printing.

NUDITY

No matter what people tell you, you do not have to compromise your values to get a job. If you ever audition for a role where nudity is required, they will inform you before the audition. You always have the power to say 'no'. Sometimes actors feel that if they don't do the nudity they will be dismissed as an actor. I understand how an actor can feel this way, but the actor holds the power in the choices they make. If nudity is germane to the role then it may be an artistic choice worth making.

Keep in mind, under Actor's Equity, the actor's union for the stage, section 46 of the Actor's Equity rule book, page 75 addresses terms and conditions on how "Nudity" is agreed to and achieved on stage. It's important you read and understand your rights if this is an artistic choice you are making. Keep in mind, you will never be asked to do nudity for an audition unless it is agreed upon in advance and an Equity representative is present. In SAG-AFTRA, the union which protects television and film actors, a rider is attached to the contract on the specifics and a lawyer is always involved. If nudity is achieved in a play at school, the department should address the artistic choice with the same pre-cautions, rules and respect as the professional unions.

FIGHT SCENES

All theatrical combat, either hand to hand or with weapons, should be staged. This means it is choreographed. If you have a fight in a scene and you have no experience with hand-to-hand combat, seek advice from someone who has training or seek training in a workshop. It's also an excellent skill to have on your resume.

SOBRIETY

It's a really bad idea to come to ANY rehearsal or performance inebriated or under the influence of anything that will impair your ability to work. It's unprofessional and could put you or your partner in harm's way. Impressions are so easily made and so hard to change. If an actor arrives inebriated at your rehearsal at school, reschedule the rehearsal for another time. If someone shows up to a performance in this condition, anonymously report it to the stage manager. This type of behavior should never be tolerated in an academic or professional setting.

AUDITIONS

Actors can sabotage their success in an instant. Here is common protocol so you can make the most of your opportunity, once it arrives.

> *READ THE PLAY! Know what you are auditioning for. Know the role and what the expectations are.*

> *Do your homework and audition prepared. If they have sides, learn the sides <u>exactly</u>. Memorize them but hold the script. If they give you a 16-bar cut in music, learn it <u>exactly</u>.*

> *Don't audition **professionally** if you don't have your professional tools. Picture and resume, website, a demo reel that is no longer than 3–5 minutes if you are auditioning for television/film. Register with the main casting networks. Have contrasting monologues and a scene or two, ready to go.*

> *Arrive on time. No excuses. If you arrive late, no long explanations. Apologize and move on.*

> *Don't wear perfume or cologne before an audition. Imagine the collision of scents in a close space. It can really bother people with allergies. Don't smoke right before an audition. You don't want to trigger the casting director into a nicotine fix instead of watching your audition.*

> *Don't shake anyone's hand unless they reach for you first. This is an odd one since you don't want to come off cold. Let them initiate the handshake. Most of time they are busy making notes in between auditions and you need to prepare, not make friends.*

- *If you are auditioning for friends, take in the room. Is it stressful, is it relaxed? If you sense they are stressed then just skip the small talk. Take your cues off the production team. Your audition is five minutes. They are in the room all day and for many days.*

- *Get in and out, make brilliant choices, and then on to your next audition. Let the work speak for you and not the reverse.*

- *Once you audition, let it go.*

PERFORMANCE PROTOCOL

You may not be aware of professional etiquette, traditionally practiced in the theatre. Here are a few:

- Once a show opens the director's job is done and it is the actor's responsibility to carry on the direction's vision of the story. Sometimes actors think once the director is gone they can embellish. In a professional setting, compromising the integrity of the show are grounds for getting terminated.

- When a show is frozen, it means you are not to change anything. Lines, blocking, characterization, or interpretation do not change. However, this does not mean you cannot discover anew using your imagination by breathing new life into it. That is the magic of theatre and why audiences attend.

- Hecklers exist. They might look at their phones or talk. They might even talk to you. Remain focused and if audience members around them don't address it, if appropriate, incorporate it into the action. If it is not, tell your stage manager and they will notify the house manager to excuse the patron.

- Respect the integrity of the story and keep personal dramas off the stage.

- Closing night gags. Never do it. Review Actor's Equity guidelines. It can get you fired.

"The magic behind every outstanding performance is always found in the smallest of details."

—Gary Ryan

CHAPTER 7

PROFESSIONAL RELATIONSHIPS

My tendency as an actor was to correct people, was to say, 'What if we tried it this way, what about if we tried that way?' That's terrible habit for an actor, but that's a good habit for director. So I became a director.

-David Mamet

BUILDING A TEAM

Throughout your career, you will build a network of people that will help you both artistically and professionally. Each relationship will play a different part in your success, so it's important to know the expectations in each of these professional relationships. Remember, no one goes through this journey alone.

TEACHER/COACH

Learning requires the student to bring their beginner's mind to class, to be open to receive what your teacher can teach you. It is important to find a teacher whom you respect and trust. You might even be a bit intimidated by them. Do they have an expertise? Do they have a body of work, training, and are they staying relevant in the field? All these are important questions to ask.

Once you find a teacher work on this relationship. Listen. Really receive. Sometimes it's hard to receive what your teacher is professing or introducing to you because you're nervous and not actively participating in the room. Maybe you have an impulsive reaction to criticism. You might defend your choice or try and justify it. Set your ego aside. If you already know then go do it.

I am always interested in what people think whether they know about acting or not. Objectivity as an artist will only serve you and the company you collaborate with. It's not about being right, it's about seeking truth and

telling the story in the most effective way possible. An effective teacher will help you find your way to this truth. Ego, defiance, sensitivity, lack of self-worth issues all get in the way of learning. If you find you are challenged by this, work on yourself. Acting is tough because you are the instrument and you are using your whole self; your past, your present, and your future. All this is part of the human psyche and it can get intense but it's also extremely satisfying once you get to the other side of the challenge.

CASTING DIRECTOR

Casting Directors are independent contractors who are hired by producers to cast projects in theatre, television, and film. They usually are casting many different projects at the same time. They seek out actors by submitting breakdowns to talent agencies who submit their clients for auditions. In theatre, producers are also required to hold audition calls for Actors' Equity Association members for lead roles, which are called Equity Principal Auditions (EPA's). Non-union performers can attend equity calls. They usually are seen by casting, at the end of the day, or in between appointments if there are no-shows. If you pass the initial audition, you will be asked to a "callback". At the callback you will be asked to read specific sides from the play for the creative team, which may include any or all of the following: director, musical director, artistic director, playwright, producers, their assistants, and sometimes co-stars.

If producers are looking for something specific, they will often post nonunion and union submissions where actors can submit themselves for auditions found on casting networks.[1] If they are interested, they will contact you. Submit cautiously.

Casting is one of the most difficult parts of the process for both sides of the table. For casting, it is hours of auditioning actors, hoping the right person for the role walks in the door. That is why the actor must *always* be courteous and polite to all casting directors and their associates. You need them and they need you, but keep in mind it is a buyer's market. There are more actors than they need to hire. Don't give them any reason to dismiss you.

For the actor it is also a complicated process because there are many variables—some you can control and some you cannot. Do you look the part? Are you the right age range? Do you have the emotional range and depth for the character? Will you take direction? Are you the correct physical type? Can you take the stage/set confidently? Are you a lot of

[1] Casting Networks are online websites where actors register to receive audition notices. The main websites are: Actors Access, LA Casting, NY Casting, Casting Frontier.

work? Are you followed by a reputation? All directors want to cast actors who they can trust will own the role and be professional. The actor's ability to handle the job is crucial and it's the directors (casting and stage) job to make sure they cast the best person in each role. The actors' job in the audition is to control what you can control and let go of the things you cannot control. Your training, preparation, and persistence are all things you can control. Your height, your gender, your nationality will affect how you will be cast, which are things you cannot control. Embrace the things in your control and release the things you cannot.

AGENTS & ASSOCIATES

You don't need an agent to initially build your resume. Do as much non-union work first to build your experience; because once you join unions this reduces your opportunities significantly. It's wise to finish school and then pursue an agent. It's very difficult to focus on both. Inevitably, both worlds will suffer.

Every agency will have different departments: commercial, theatrical (film and television) and theatre, print, and modeling. Smaller agencies focus on one department, such as commercials. Do your homework on the agency before you get an interview. Most agencies now have an internet presence. Agents' associates are often running the front office and before long may even be your agent. Remember Rule #6? Don't burn bridges. Keep this in mind when someone is busy and maybe curt with you on the phone. Read the tone. Usually, it's because they are in the middle of breakdowns and busy. Find out what form of communication they prefer and what hours are best for calls.

Theatrical (film and television) agents differ from commercial agents. When agents are looking to add to their roster both consider training, experience, and whom you have worked with. Theatrical agencies are interested in your acting ability and range, as well as your commercial viability. They are often looking at credits, demo reel (how you look on camera), and if they need your "type" in their roster. Commercial agencies will consider if you fit the demographic on products currently being sold. Often commercial agents will take a risk on newcomers because less acting ability is demanded of the actor where likability and accessibility are primary.

Also, keep in mind the percentage of commission. You make 85–90% of the money, so that means you do 85–90% of the work. The agent opens the door for you to do your work.

The business of getting an audition changes rapidly. Many agents will ask you to self-tape for television. Currently, both in television and theatre more auditions are still in person. If you're auditioning for film and television, many actors don't know, is that you can ask to see your submission report every once in a while. I wouldn't ask for it weekly or even monthly but perhaps twice each season. The submission report lists what television shows or plays the agent has submitted the actor for and you can compare the number to your actual auditions and call backs. If the actor is not getting auditions it might mean pictures may need updating. If you're getting in the room and not getting called back, it may be time to take an on camera audition class or acting class to see why. If you're going on auditions, getting called back it's only a matter of time. Just keep doing what you're doing and trust the work. If you have been with the agent for over a year, getting called back regularly, in class and your feedback is positive you may want to consider finding a new agent. Most of the time getting cast does not have anything to do with your talent, especially if you're getting called back or pinned. Pinned means it's between you and someone else and it's a courtesy hold on your schedule. If you have established relationships with agents and casting, trust this. Work on your craft in between auditions and call backs. Do a play. Learn new things. Develop as a person and as an artist.

MANAGERS

There is a phrase in the business: *you don't need a manager until you have a career to manage*. Navigating these two relationships can be tricky, not to mention a hefty payout. (Managers commission is typically fifteen percent, but it can vary). Some actors find managers help them network in order to get in the door to be seen for auditions. Be cautious. Do your homework and if they don't have a track record—you may not want to take the risk. Get in a play, get rave reviews, be seen and you will be surprised who will come to *you*.

PRODUCERS/WRITERS

A career can take many different paths. Building relationships with writers and producers is an excellent way to become part of a network of actors who work on new plays and new projects, which can lead to bigger things. Theatre companies are another way to keep working on your craft, where you can learn how to produce and write projects for yourself. Many accomplished actors are associated with theatre companies who write and produce with their friends. This seems to be where the industry is headed with webisodes, independent films, and original material.

THE DIRECTOR

The director cannot tell the story without the actor, nor can the actor ever have perspective about their performance without the director. Ideally, the relationship is built upon communication and trust; they can count on one another to deliver, when it counts the most. This is why actors and directors repeatedly choose to work with the same people.

I asked a community of theatre actors what they want in a director and what directors want from actors. The themes were the same: Collaboration. Vision. Creativity. Imagination. Brilliance. Open mind and heart. Respect. Preparation. Freedom. Choice. Interestingly enough, both actor and director want the same things.

Directors want to stay true to their vision of the play and get the best possible performance out of their cast in a finite amount of time while serving the playwright. The director sets the tone on how the play will be worked on. At best it is collaboration, but since the director's name is usually under the title alongside the playwright unless you have star billing, they have the last word and it is in your best interest to give it to them. However, I don't know many directors that will force any actor on a choice the actor does not feel comfortable with. It doesn't serve them or the play. A great director knows that everyone involved has a function in the storytelling and collaboration is the journey.

THE ACTOR

Actors new to the field don't often know what is expected of them. It's impossible to figure out exactly what a director wants for any given role and I can speak as a director, sometimes we don't know, until we see it. I will say that I have often gone into a casting session with one idea of the character and an actor will change my mind.

The actor that changed my mind, brought in a very specific point of view about the play, character, and given circumstances. They also bring their best self. They are at ease and having a great time. Recently, I was casting an original adaptation of an old story and had preconceived ideas about who the character was. I knew the actors auditioning and one actor who I did not read for the role came in and read by chance and blew me and the playwright, away. I convinced myself that this was really a fluke and then at call backs I would see what I was expecting. At call backs this actor convinced me that this was the way to go. The actor brought something fresh, new, and exciting to the role that I had not expected.

Bring yourself. Your preparation. Your love for this craft. Your professionalism. You desire for the role. Leave at home your personal dramas, your insecurity, your self-doubt, and the more prepared you are, the less nerves will affect your work. Find the humor, just the right amount of self-deprecation while keeping your focus in the room. We can all get caught up with validation, celebrity, attention, what people think of us, or the fact that they don't think of us, but art will sustain you. It will fulfill you and above all, it will give you a greater purpose for which to share your craft.

In class, I talk about core artistic values. What gives you that purpose or reason to study a field that has no guarantees? The answer always boils down to a version of this: *it makes me happy to make people feel something. I want to inspire, change people's point of view, make them aware of stories that are not their own.* Art has a higher purpose and I believe you are chosen to be an artist. I believe that it's not a choice but a calling to make your life about art. Think about it. Art makes the world meaningful. Purposeful. No career has its guarantees. It has been said, if you love what you do, you will never work a day in your life. That doesn't mean you won't work hard. Work smart. Ask the important questions. Ask inspiring questions rather than muscling through.

There will always be naysayers. Always. There will be people that tell you, you are too old, too young, too whatever. They will try and attach everything you do to a monetary value. Did you get paid? Obviously, you want to get paid. That is the goal but you never choose acting because you want to be rich and famous. If you have the will to act, nothing will stop you. A rejection will not stop you. It might disappoint you but it won't make you throw in the towel. If you are a good actor and you love it you will find work. Happy people are a magnet. People are drawn to them. So choose what makes you happy. Once that changes it's time to do something else. I encourage you to be specific with what you want with your career and prepare for it. Keep filling your well as an actor. Travel. Live. Fall in love. Fall out of love. Read. Learn something new. Become. Grow. You are the instrument, so keep tuning yourself and developing your humanity. If you do it right, you will get better with age and you will not age out. Many actors I know personally are proof of this.

When students succeed in class they often come to me and ask me how to get into show business. "How can I start working on television?" They are enthused by their progress and believe now they are ready to get into show business. With every grain of restraint, I try and not squelch their enthusiasm but give them a no-nonsense answer. I ask them to do research on their favorite actors. How they got into show business, where they trained, how long, how much theatre did they do? Each person they

research is slightly different but the connecting theme is that it takes time and before they could get the job, they had to know what they are doing. They had experience. Insecurity is built into our human systems for several reasons and one of them is not being prepared. Build on your strengths while you're in school. Know that part of your training is making mistakes. Allow yourself this luxury. Once you own your process, create a body of work, then you will have the confidence to put yourself out there and not much will throw you once you know what you're doing.

"If you want to reach every person in the audience,
it's not about being bigger, it's about going deeper."

—Sanford Meisner

CHAPTER 8

PROFESSIONAL PERSPECTIVE

Sometimes when you say, "please pass the salt", what you want is the <u>salt</u>.

-Brian Dykstra

There comes a point where the actor has to ask himself/herself some hard questions: Where do I fit into the commercial world?

It's early in your training to fully answer how commercially viable you are, but certainly you are aware of where your strengths exist; empowering yourself with knowledge is the first step towards figuring it all out.

Actors often try to mind-read what the director is looking for or why certain people get cast all the time. The following interviews are from seasoned professionals from both sides of the conversation: Director, Actors, Agent, Casting.

Director and Educator: Professor, Mark Ramont, Circle Repertory Company, NYC, The Ford Theatre, Washington D.C., CSUF

From auditioning...the actor who is trying to figure out what I want, is doing me the greatest disservice. It's not about what I want; it's what about what makes the play work. They have as big a responsibility as I have. I have to make sure it fits into that framework but it's as much their responsibility to make the play work as it is mine and I trust them to bring their point of view, their experience, their heart, their imagination... those are the things we want. I don't want someone who thinks there's a right way or a wrong way to do it and come in and give the right way or try and figure out what I want. Figure out what's making this person tick. That's the actor's job.

...We cast them for a reason ... and usually it's because they did something great at the audition. In some way, they need to build off of what they did at the audition.

He talked about working with two-time Tony award winner Cherry Jones, while assistant-directing the celebrated director Anne Bogart on Baltimore Waltz at Circle Repertory.

Up to that point I never had seen an actor really invest so much into the given circumstances that what they were creating, make a world that was totally not real, real...it was one of the most heartbreaking performances...and it was pretty much that way from day one.... Anne provided the context but once she laid out the ground-work for Cherry, it was all there.[1]

I asked Mark about the transitioning from training into the profession and what are the common mistakes new professionals make.

I can't work with the actor anymore who doesn't say their impulses are important, they need to be free to bring their impulses...I tell you what I avoid in an actor, like the plague, is the resistant actor. For my money there isn't anything worse than the actor who says my character wouldn't do that. My first rule is you try everything, that is the only way you know.

Mark Ramont was the Associate Artistic Director of Circle Repertory Company in New York City and Director of the Theatre Programming at The Ford Theatre, Washington D.C. He has worked with celebrated directors Anne Bogart, Marshall W. Mason, Jeff Calhoun; playwrights Paula Vogel, Craig Lucas, Paul Zindel; and with actors Joe Mantello, William Hurt, Lois Smith and others. He is currently an Associate Professor, where he serves as Head of Directing at California State University Fullerton. While he teaches directors, he finds student actors can be inconsistent with what they bring, *after* they are cast.

Actor, Playwright: Brian Dykstra, New York City

There was a time I was mad at directors but it's been years. I was just saying to Margarett (Perry, his wife, a professional director), wow, I have had this lucky run of talented directors. And Margarett said, "That's not them, it's you". She's right. If you get a lousy director you don't fight them, you just figure out how to get around them.

...What you do is identify what has meaning to you and...to the character. Our job is to just create behavior and the director's job is to say...I like choice "B". When you're young, teachers are always hammering you about, you've got to come in with active verbs, active choices, after a while there's no other choice you make, every choice

[1] Anne Bogart is one of the most collaborative directors we have in the American Theatre today. She has created a community of collaborators by passing on her philosophy to theatre artists all over the world through her work with The SITI Company. Bogart's language is practical, yet imaginative. She empowers the actor with structure yet allows them freedom to discover through play, and then selects the best choice that serves the story.

you make is an active choice so that kind of work is not required anymore, consciously, because it's your instrument.

Brian Dykstra has worked beside young professionals as well as seasoned celebrities and I asked him if he had any other observations on the differences.

Don't learn your lines with a cadence attached. Then you get stuck in a delivery. Also, people still sometimes wait. And it seems to me the least you can bring to rehearsal, is to make demands on fellow actors and rise to the occasion when demands are made on you. If somebody makes a strong choice, a large percentage of actors shrug, look at the director and say, "what do I do with that"? And you just killed whatever possibility there was for that strong choice to effect and make a scene explode. It seems you could meet it with a strong choice. Make demands and be willing to have demands made on you. Step up and answer to them. The only way to do that is, be prepared. I know it's always fundamental. When you're struggling in acting class. It's fundamental. When something bothers you now, you know, it's fundamental. Be prepared, know what you want but stick in your back pocket, others and know what it means to you. Even at this level (Broadway), sometimes we hide from conflict and that's not good for theatre. Learn to love conflict. Make positive choices. Iago loves what he is doing and the guy suffering and dying from cancer, find humor in it. Nobody wants to see you wallow. Poor me, means I (audience) don't have to worry about you. If you are whining, stop it. With young actors there is the mistake of embracing of this earnestness, **I'm a good guy.** Yeah. Just **be** it. You don't have to be a **GOOD GUY.** That earnestness has to be stripped away. It's just an idea young actors have about acting that doesn't help…It's like pushing but that's more indicating. Earnestness. Sometimes when you say, "please pass the salt", what you want is the salt. Not everything is the most important thing in the scene. You may not have the most important things in the scene. Your job may be to watch someone go through a breakdown and it's really cool to just watch…and just respond. No need to telegraph or magnify. If we just talk and listen, that's cool too.

Brian Dykstra has been a working actor in theatre, film and television and a playwright. He has performed on Broadway (*Lucky Guy* with Tom Hanks), off Broadway and in numerous regional theatres, calling The Kitchen Theatre his theatrical home.

Actor: Brian George, Los Angeles

What do you think is the responsibility of those who train actors today?

I suppose my first thought is that one of the responsibilities of the acting teacher should be to stress the primacy of the text. The student should know that the text isn't a suggestion or a road map. It is the carefully thought out creation of another artist, who wants to see their creation performed as they wrote it. If a passage is difficult

for the young actor to make sound "natural" or "believable," it is not the actor's job to "fix" the text, or to edit it to his or her comfort level. It is the actor's job to find a way to make even formal or artificial speech believable. It was written that way for a reason—assuming we're dealing with a talented writer, of course! (This, by the way, is moot if the play is contemporary, and the writer is an active part of the creation process and is there to edit and make the changes required, as he or she sees fit.)

As to acting technique, there is a tendency (or at least there was when I was coming up) to beatify the bringer of the wisdom! Whether it be Stanislavski, or Strasberg, or Meisner, or Stella Adler, or Uta Hagen, or Boleslavsky! Take your pick. They are merely "techniques," not holy writ! They were created to allow a performer to reach a version of "truth" in their performance and then provide the tools to allow the actor to repeat that truth night after night without relying on stale, rote behavior. Ultimately, each actor—through a kind winnowing and cloning process—has to come up with their own version of a "technique" that works for them. I loved Uta Hagen, but had to let go of her dictum "to hold on to the script for as long as possible." It never worked for me and, in fact, caused me more trouble than helped me!

In transitioning from theatre to film to television what are the biggest challenges for the actor?

I started in theater, moved to improv comedy with The Second City, then started working in television and films, with occasional forays back into theater of various sizes. There are obvious things you need to learn when moving from one medium to the other. Stage requires an "awareness" of the audience, without "playing to" the audience. Your quiet "inner" moments have to be seen and heard by someone twenty rows back! It requires you to be aware of the space you're trying to fill. A large proscenium requires more from you physically and vocally than a small studio space. A raked audience literally means you have to lift your face when you speak, so that the person in the back can see you too. It's incumbent on the actor to make an artificial situation as "alive" as possible. (I came of age as an actor in the shadow of "the method"! So many truly great "method" actors! And so many bad choices made by less great actors in the name of "the method"!) This same sense of awareness has to be part of the actor's toolbox on a film or TV set. Is the DP (Director of Photography or Cinematographer) using a wide lens, or is this an extreme close up? Each lens will subtly affect your performance. Where is the camera situated? If you're in a large crowd scene, with the camera far away, you might want to "favor" the camera so you don't upstage yourself or your partner.

What advice do you have to young actors who don't want to be type cast?

As for "type casting," very few actor's escape it. It doesn't mean that a meaningful career can't be had, but there has to be a recognition that not everyone is going to have Meryl Streep's career. You can accept that fact or not. Whatever decision you make brings its own reward and problems. It's worse in TV and movies, but it exists in the theater too, just with

a looser *rope! It's a sad reality that each of us has to deal with (Unless, of course, you start your own production company and cast yourself and your friends however you please!).*

What is the biggest and most common mistake you see young actors make today in a professional setting? (Is work ethic something you see lacking?)

I've had the great luck to work with many young actors who have been prepared, have been respectful of the process, and have been grateful for the opportunity to be able to make a living in such a creative and fulfilling way! I can't say I've worked with any divas, thankfully. I suppose the lesson for students of theater is to remember that it's a cooperative medium. No one person's creative journey should hold the process hostage. Everyone, including the "stars," is in service to the play and the director's vision. Private work, generally speaking, shouldn't be done in public. It takes up valuable rehearsal time and frustrates everyone else. Of course, this is all meant with the caveat "within reason." Many times it's unavoidable, and useful to the process, to delve deeper into the psychology of a moment, if it affects the scene. Also, it's not up to the director to find your "motivation" for you. You should be as self-reliant as possible. You bring your work to the stage and then you let the director mould it to fit his or her larger vision. Whether it be for a movement across the stage or for a specific behavior, finding that motivation is the private work of the actor. Again, if you vehemently disagree with something then take it up with the director, in private, after the rehearsal.

You've done hundreds of televisions shows and been a regular on multiple series. Why do you think your work on Seinfeld is so memorable?

Thank you for your kind words regarding "Seinfeld." Why was Babu memorable? Well, he really was a beautifully realized character on the page. It also didn't hurt that I'd known characters like him all my life. It helped enormously that there was a feeling on the set of collaboration and joy. Every guest role was as fleshed out as the regular roles. Every one's contribution was valued and encouraged. Plus you had two comedy giants who understood the creative process from both sides of the camera.

Please offer any other advice I may not have prompted in my questions that you wish to elaborate on.

I think we spoke on the set (NEW GIRL) about this, but I'll reiterate. It's obviously incredibly important for an actor to be versed in the various forms of drama, from classical to modernist, from period pieces to theater of the absurd, from commedia to clowning. But we live in a television and film town and, eventually you're going to be cast in a soap opera! Or a third-rate, horribly written, hit sitcom! And you're going to have to come up with the goods! So, do the great canon of the theater, by all means, but don't shy away from trying to breathe life into mediocre screen writing! It's a heck of a challenge!

The youngest of four siblings, Brian George was born in Israel to Jewish parents in July 1952. Both of his parents had immigrated to Israel from India. It was at the University of Toronto where he became involved in theatre. George left before graduation and formed an unsuccessful theater group. He joined The Second City,

where he trained with comedy greats including John Candy, among others. His career in acting and voice-over work has flourished ever since.

Casting Assistant: Skyler Zurn

If you had advice for actors new to the profession either on stage, television or film what would be your number one piece of advice?

Every relationship you make is an important one! Talent only gets you so far in this business and you may have everything it takes to be a star and just not be in the right place at the right time. Making as many connections as you can may bring you that big shot that you never knew you needed. It is important to treat everyone you meet with respect, positivity, and kindness because you never know who may help you.

You see hundreds of actors a day come in for one part. Why does one actor get the part over another?

There are so many reasons that a person may not get a part that has absolutely nothing to do with their audition. That is why it is good to always leave the audition room wiped with a clean slate and ready to go to the next one! However, when an actor comes in and lands a role it mainly has to do with the authenticity they bring to the audition. The stars have to align meaning you have to look, sound, act, speak and be the vision of the production team has in mind. Or, you have to spark something within the character that brings it to life. So, when it comes to landing the role, just become very familiar with the material at hand and let yourself fall naturally into the character as much as possible.

What do you see the biggest mistakes actors make once they get in the room?

Actors make the mistake of being what they THINK the casting director wants to see instead of interpreting the material themselves and bringing life into the script. That does not mean put your own twist on the material at hand, it just means don't try so hard. You alone may be just what is needed to create a character, you just have to learn how to present it in a way that connects with the entirety of the vision at hand.

Acting in Los Angeles is like a board game; you may be taking 5 steps forwards and 3 steps backwards regularly, but when you get that prize the difficulty of the game seems more rewarding than if you just won the golden ticket to the end! Finding passion can surprisingly be difficult in this industry at times because actors tend to let themselves get very discouraged after a while and that desperate desire for a job can sometimes rub off into the aura in a room. One needs to learn how to maintain a positive outlook and attitude for what may seem to be like forever and instead of investing energy in the hardships of Los Angles, put that energy and effort into the grind and connections you could be making. This industry is so exciting because of the effort it takes in achieving what you came here for, just make the most of the journey and don't get impatient. There are so many roles out there! You just need to find the one that fits you.

Skyler Zurn is an Assistant for Bernie Telsey Casting in Los Angeles, which casts *This Is Us*, *Smash*, *Masters of Sex*, and many other television and film projects. Skyler was an acting student of mine five years ago and half-way through college decided to change her course from theatre to Communications. She said she never looked back and found her niche in casting.

Agent: Mariko Ballentine, MINC Talent Agency, Los Angeles, California

Remember something . . . It's not your business to play Casting Director.

If you are in the lobby comparing yourself to all the other actors in the lobby, then you have already lost the part.

If you read the breakdown and it says Caucasian and you are Black, or it says chubby and you are thin, if it says Brunette and you are Blonde . . . If you have already gotten the audition . . . make the assumption that the CD is open to some variety.

Sometimes, casting as well as the Director, doesn't always know what they want until they see it.

This is where your AGENT comes in. It's their job to submit talent that fits the role.

So if you are not looking the way your agent remembers you, or your head shots are old, or if you are not really fluent in that language you claim to be . . . then there is a mismatch and that wastes everyone's time.

Also remember we want your head shots to look the way you "really" look . . . so don't go spending tons of money to get "Star-Shots." They won't help.

Part of your journey as an actor is to "Know thyself" . . . so know who you are and what you do best and get an affordable head shot that not only looks like you but gives off the essence of who you are.

Mariko Ballentine was born and raised in the Catskills of New York. She studied Theater Arts at SUNY New Paltz and moved to Los Angeles in 1982. Mariko started casting commercials in 1984 and then went to the "other-side" and became a Theatrical Agent with MINC Talent in 2012. Mariko lives in the "Valley" with her cat and two dogs: Bailey, Sammy and Riley.

Artistic Director/Director/Educator: Brian Kite, UCLA, Professor and Chair, Department of Theater, Film and Television. Director and former artistic director of award-winning La Mirada Theatre for the Performing Arts.

I love taking a chance on a beginner; the same reason I love teaching my undergrads. I love the freedom. I love the openness. I love their willingness to try and take risks and that's really all I want in an actor anyway. I do think there is something to that transition. I mean, when you're in school your directors are often your teachers and you do look at them as teachers and okay

(the actor says), "tell me what to do". When you move into the professional world, my hope is that I won't have to tell them what to do. My hope is that they will give me choice "a", "b" and "c" and I'll say, I want three-quarters "a" and a quarter of your "c" choice.

I always come to each project as an artist willing to work with the other artists. When an actor and director meet in the room it's not "I'm a director, do this". Hopefully, . . . we're two artists, who are going to work together. I think a director's job, especially on a musical but really in everything, is to inspire the artists around them to do their very best work, right? That's what the director does, so it's the same thing when I get in there with those young actors. I treat them as professional actors and hopefully they respond that way, they give it back to me, they step up, they make choices and it's exciting to see their choices, their untainted, unscarred perspective on the roles and hopefully they're going to bring things to the role that I never dreamed of. I do think they get startled by me saying, "Alright what do you got?" As opposed to (them saying), "What do you want, you're the director?" I think there is a transition to professionalism. I've got a lot to worry about, that's why I'm hiring you, that's why you're the actor, you get paid, go do your job, make those choices, be specific, let me guide or tweak it. Be professional. Take it seriously. Sometimes when I use actors just out of school they come into the first day of rehearsal and say, "I'm ready to start". I think "ready to start", you should have started three weeks ago. What do you mean, ready to start today? My show goes up in 14 days; we have 12 days of rehearsal and two days of tech.

I asked Brian how he handles the pressure of time[2] and still manages to get truthful performances and make the play your own.

When people are trying to just duplicate the original production, which is fine if you want to give the original production credit, you don't know their process, you don't know how they got there so it's just a copy without the underneath stuff going on. Since I am asking our actors to create it from scratch, to start at the beginning, to say yes, great artists created the original production but they are no greater than us. We are also great artists. Let's start and create our own things, not every choice they made was the right choice. It worked great for them but maybe there are other choices too? I try to remind my team of that and we go into it and try to make it specific. I have a "specific" meter in my head and if I don't get it. . . I just hate general, I don't allow general playing, you cannot just play sad. One of the traps of quick productions is, I just have to play sad because I don't have time; that's not true, there is time. Everyone just does it because that's what we're doing on this production. Play action. Be specific.

I asked Brian, what is the perfect audition?

I know it when I see it but how to put it into words. Honesty, truth, and specificity. I love the audition where the actor is so specific and I get every word or and I'm surprised. They make choices that are interesting, specific, and spontaneous in the moment. I am often asked, what are you looking for? I have some ideas but that doesn't matter to me. I am looking for the best actors and I do think actors should know that I am looking for someone I want to work with. I'm

specifically talking to you in the room when you come in or after you audition and checking if I like you and if you get the joke I just made. Did you know I just made a joke? You could be an incredible actor but if I don't want to spend two weeks in the room with you, I'm not going to hire you. I use to make that mistake when I was a younger director. I would just hire the actor who is incredible and I can see they're going to be hard to work with but it will be worth it. It's NOT worth it. It hurts the rest of the production. You have to spend too much time focused on handling their attitude or issue.

It always matters how you treat the person who checked you in, how you handle yourself in the room how smoothly you get out of the room at the end of the audition, the most difficult part of the audition, the exit, and your willingness to take my adjustments. It all matters.

Brian Kite has won Ovation awards for his directing and producing, serving as producing artistic director of La Mirada Theatre for the Performing Arts from 2008-2015. He has directed abroad and currently serves as the Chairman of UCLA School of Theater, Film and Television. He is also an award-winning actor on both stage and screen.

Russian, American Actress in Theatre, Film, Television: Svetlana Efremova, California State University Fullerton, Head of Acting

Svetlana Efremova has been my friend and colleague for the last twelve years. In our many discussions about art, life, theatre, and our similar cultures, I would be remiss if I didn't share her voice in this book because of the significant impact she's had on me as an artist. She continues to teach acting globally, continues to work as an actor in film, television, and theatre, has had an incredible impact on artists with her unique point of view.

You have been a professional actress both in Russia, in the theatre and in America on television, film, and theatre. You have taught upper classmen and graduate students for the last twenty years and more recently launched a film school in Moscow five years ago. What is your advice to the beginning student who is considering this profession for their life's work?

My biggest advice to people who are starting to express themselves in any art, let it be music, theatre, visual art, is to really, really know who they are. Even if at that early stage of development, they need to find their theme. I'm always teaching to students: what is your theme? Meaning: what is your voice today? What's your message today? Over time it has to change. We are never the same. We grow. Somebody betrays us, we discover something incredible, like love, you know, we travel, we see other cultures, we discover friends from another race. Anything changes us . . . who we are. Environment, politics, new president, you name it. It changes your thinking. So, at one stage of your

life you're about acceptance and your need for a foundation and another time it is about being a rebel about standing up for what's wrong. So you need to find your voice, your theme. And listen to yourself and see how it's changing and that's what you need to bring to your art to make it personal. That's what makes acting personal. How does this character speaks to me today? It will change. It's very liquid. It's not dogma. Sometimes people don't understand. They're stuck. They are stuck with the Peter Pan desire not to grow up but at 22 they are already a young man and they still approach everything as a child, as a boy and that's wrong. You're different. So, you need to listen to your instinct, listen to your voice. That would be my number one piece of advice.

You have been asked to speak at an Economic Global Conference in Russia this summer, what is your take on the acting profession from a global perspective? Since you worked, trained, and taught in both countries you can clearly see the different approaches to learning. How can we better prepare American students to learn?

I was very surprised when I received an invitation, I was honored. And so, the reason they invited me because they were fascinated with being Russian and having a Russian education and foundation while I teach at an American institution and now, I also teach an American technique (Yale School of Drama). So, they would like to know also what is the common ground and the differences in each other and in my opinion that is extremely valuable. Because both perspectives Russian and American education, there is absolutely one main foundation and that is to make our students express themselves, make them better and in my opinion learning is not just information you receive but what you do with that information, how do you digest, and how you express it in your profession, art, theatre. The biggest difference of course is cultural because American cultural is very different than Russian culture, people are much more careful with how they express themselves because they are very concerned with being politically correct, which Russian's do not have that filter at all. Based on the Russian culture and history, you know people are much more blunt and honest but it can hurt somebody's feelings but it can also bring an incredible, different sense of truth. As a result, Russian students get into a sense of truth much easier than American students. However, in American students, which I would like Russian students to learn from them, is the vulnerability. In Slavic culture, men, especially men being raised as being macho, you know you don't cry, you don't reveal your weakness, which in American culture, it's okay. That's why American students are easier to go there to the vulnerable places which take Russian students much longer. And the other thing is a constantly changing sense of truth. Every generation we teach, it is amazing to me how different the sense of truth is. Many years ago, it was much more appropriate to express yourself through emotions, screams, yells, you know, big emotions. Now because of technology and people are on their phones and texting is easier than talking, people are less emotional, they're much more quiet, they express themselves differently, in more watercolor, rather than an oil. There are more nuances,

there is a more sensitive way at approaching sense of truth. It's more, quiet. There's less intensity. And so, you can adjust to that too. Both cultures teach me a lot and I'm trying to go back and forth to see what can I bring from one culture to another. Russian students are much more connected to their bodies, they're physically much more connected to their bodies, they are not afraid to touch, they're very physical, they consider it normal to hug and kiss, even men kissing men, it's okay to kiss, it doesn't mean it's romantic. Spacial relationships are different. It's fascinating to learn from both cultures.

Students who decide to become actors often don't understand the difference between being an actor and being a celebrity. Can you speak to these career paths?

That's a good question and I was lucky in my career, you know I've done 45 films and television. In London, there were pretty—profound names and a lot of them were big celebrities. Like Harrison Ford, Jeff Goldblum, Ewan McGregor, Michelle Feiffer . . . big names and what people don't understand about celebrity is what makes a person a celebrity is a crowd, not themselves. As a human being and as an actor, they still very much all about craft, pursing their profession, expressing their being and so that's what being an actor is, constant work on yourself. Constant. It has nothing to do with glory. It's what Chekhov says in Sea Gull when Nina says "and now Konstantin, I understand it's not about glory or fame or what I dreamed about but it's about endurance you carry a cross and you have faith" and that is what an actor needs to know it's about having faith in art, faith in profession and constantly develop yourself, changing yourself, working on yourself and celebrity is just a status that is created by the people who surrounds you, it does not have any civic duty, it's just a result, which you can enjoy or you can hide but it shouldn't be a goal, ever.

Svetlana Efremova-Reed has served as a Head of Acting at California State University Fullerton for years. She received her MFA from Yale School of Drama and BFA from St. Petersburg Academy with numerous theatre, film and television credits to her name.

CHAPTER 9

AFTERWORD

Electric communication will never be a substitute for the face of someone who with his or her soul encourages another person to be brave and true.

-Charles Dickens

Choosing a life in the theatre is a courageous path. Many students admit they are in denial of wanting to act because no one in their family has paved the way yet they cannot imagine doing anything else. I say carve out your path big and wide and shout out loud, *I am an actor?* It is a time in our history where we need artists more than ever. Actors, musicians, painters, dancers anyone who will persevere with passion to remind us who we are as a people through story and expression. When I ask students why would you choose an uncertain path such as acting, their answer is *to make a difference.* We can agree the emotional connection storytelling has to humanity is what pulls us to this dream.

There are interesting insights why certain people succeed and some don't. Some people are inclined to take risks and others wouldn't dare. It is my belief that acting chooses you but where it takes you, depends on your grit.

Grit comes from a deep desire to impact others besides ourselves. It can change people and make the world better. *ART SAVES LIVES*[1] through compassion, empathy, and the stories which connect us to understanding each other beyond race, gender, sexual preference, political beliefs, and religion.

If you're fortunate enough to have acting choose you, for the rest of your life, you will spend long exhausting hours with interesting people, different than yourself who will become family, who will understand you better than your own. You will learn new things. Your world will be bigger and

[1] Duckworth, Angela Grit, The Power of Passion and Perseverance 2113

our world will be better. It is my hope that this book offers you an open door to ownership. Ownership of taking charge of what is yours. Taking charge of your time, your education, your art, and your work.

I admit I watch awards show. My favorite awards show is the SAG-AFTRA awards because it's celebrates the actor. My favorite moment on the award show is not *and the winner is,* it is the introduction that begins the ceremony. Many actors started out where you are. In class. Studying. Wondering how this career is going to happen. Denying their dream. Somehow the journey begins and if you stay on it, cultivate your talent, are patient, you can someday call yourself an actor.

Actors ask *Who am I?* Often we let others dictate who we are or who we are not. The quotes below from SAG-AFTRA Awards are reminders *To Thine own self be true,* from actors who have been where you are now and still taking the journey.

Five years ago I walked into an audition. The role was for an ex-runway model with a white gardener. I chose to go in 5'2 and Mexican and I got the part. I am Eva Longoria Parker and I'm an actor.

When I was a little girl growing up in NYC, all I wanted to be was Scarlet O'Hara . . . Oh well. I'm Jennifer Anniston and I'm an actor.

. . . Went to college on a basketball scholarship never truly fulfilled, then in my senior year I had an opportunity to do a play called SPUNK. For the first time in my life I felt like I was at home. I Mahershala Ali and I'm an actor.

I have often been told I am not thin enough, I'm not white enough. I'm not short enough. I'm not man enough. Dammit, I am enough. I'm Queen Latifah and I'm an actor.

In 1995, I decided to move to New York and become an actor. It was very exciting and very challenging. It was the highs of getting the gig and the frustration of not and a ton of rejection and never knowing where your next job is coming from and NOW . . . it's the exact same thing. I am Tony Hale and I'm an actor.

To watch the entire segment, visit *SAG-AFTRA:*

http://www.sagawards.org/about.

BIBLIOGRAPHY

Brestoff, Richard. *The Great Acting Teachers and Their Methods*. Smith and Kraus Publishing, Lyme New Hamshire, 1995.

Carnicke, Sharon M. *Stanislavsky in Focus*. Harwood Academic Publishers, 1998. Reprinted, 2003.

Carnicke, Sharon M. "The Knebel Technique: Active Analysis In Practice." *Actor Training, edited by* Alison Hodge, Routledge, 2010.

Chekhov, Michael. *Lessons For the Professional Actor*, edited by, Deirdre Hurst Du Prey, Performing Arts Journal Publications, New York, 1985

Clurman, Harold. *The Fervent Years: The Group Theatre and the Thirties* Da Capop Press, Inc. A member of the Perseus Books Group, 1983.

Duckworth, Angela Grit, *The Power of Passion and Perseverance*, Simon & Schuster, 2016.

Hagen, Uta. *A Challenge for the Actor*. Harold Scribner Publishing. 1991

Robbins, Mel. *The Five Second Rule, Transform Your Life, Work and Confidence with Everyday Courage*. A Savio Republic Book, 2017.

Manolikakis, Andreas. *Our History*. theactorsstudio.org/studio-history/

Marowitz, Charles. *The Michael Chekhov Twist*. //www.americantheatre.org/2005/01/01/the-michael-chekhov-twist/. Theatre Communications Guild Publisher, 2005.

CPSIA information can be obtained
at www.ICGtesting.com
Printed in the USA
FSOW03n0455230118
43657FS